the digital shoebox

How to Organize, Find, and Share Your Photos

Sarah Bay Williams

Peachpit Press

The Digital Shoebox: How to Organize, Find, and Share Your Photos
Sarah Bay Williams

Peachpit Press
1249 Eighth Street
Berkeley, CA 94710
510/524-2178
510/524-2221 (fax)

Find us on the Web at www.peachpit.com
To report errors, please send a note to errata@peachpit.com
Peachpit Press is a division of Pearson Education

Acquisitions Editor: Nikki McDonald
Project Editor: Valerie Witte
Developmental Editor: Elizabeth Kuball
Copyeditor: Kim Wimpsett
Proofreader: Scout Festa
Production Editor: Becky Winter
Composition: Danielle Foster
Cover and Interior Design: Mimi Heft
Indexer: Valerie Haynes Perry

ISBN-13: 978-0-321-66049-7
ISBN-10: 0-321-66049-8

9 8 7 6 5 4 3 2 1

Printed and bound in the United States of America

Acknowledgments

This book is dedicated to the memory of my grandmother, Lydia Emmet Williams, known to me as Gummy, whose elegance taught me in unspoken ways what it means to be organized. I owe big thanks to Peter Krogh, not only for being the digital asset management guru that he is but also for making the time and effort to help me turn an idea for a book into a real book. To the team at Peachpit and all who worked on this book, it's been a genuine pleasure working with you—Nikki McDonald, Valerie Witte, Elizabeth Kuball, and Mimi Heft, thank you. To my agent, Matt Wagner, you swooped in like a superhero and made it all happen—thanks! Thank you, Colleen Wheeler, a million times, for being on my side, and thank you, Judy Walthers von Alten and Derrick Story, for your brilliance and help in making this book. Thank you to my one-of-a-kind mom for lending me her computer for so long (which has proven to be impervious to spills). Thanks to my dad for not only passing on the genes that instill in me a passion for both art and technology but for also being a great friend. Thank you, Christian Kasperkovitz, for making such magical drawings. And most of all, thank you, Paul Gachot—since we agreed that you can't be *my* muse (according to gender, but I hope *I'm* yours), I'll just call you He who makes my heart sing.

Image Credits

All illustrations in this book were created by Christian Kasperkovitz.

Unless otherwise credited, all photos are by Sarah Bay Williams.

Contents

Introduction . vii

part 1 **Your Photos**

one **Before You Take Photos**

Step 1: Set Your Camera's Clock and Calendar . 4

How to Set the Date and Time . 8

Step 2: Don't Let Your Camera Reset File Numbers 13

How to Turn Off File Number Reset . 14

Step 3: If You Shoot JPEGs, Set Your Size and Quality to High 15

How to Select High Quality and Greatest Resolution
for Your Photos . 16

Beyond the Box: Shopping for a Camera . 18

Buying a New Camera . 18

Comparing Features. 19

two **Making a Home for Your Photos**

Step 4: File Your Photos by Year and Month . 23

There's No Wiggle Room Here . 23

How to File Your Photos by Year and Month. 24

Step 5: Never Alter Original Files and Camera Filenames 31

Beyond the Box: Where to File Movies. 33

three **Navigating a Sea of Photos**

Step 6: Keep a Calendar . 37

A No-Brainer Way to Browse . 39

How to Set a Default Application to Browse Photos. 39

How to Browse a Month of Photos . 40

Six Steps Down, One to Go . 42

Beyond the Box: Pro Navigating Techniques. 43

Professional Image-Browsing Software . 43

Keywords—Tag! Your Photo Is It . 45

Printing Contact Sheets. 47

four **Preserving Your Photos Forever**

Step 7: Back Up Your Photos . 51

The Master Version of Your Photos . 51
A Recipe for Backup . 52
How to Back Up Your Photos . 52
Purging Photos from Your Photos-Download Folder 54
When You're On the Go . 54
Murphy's Law in Action . 56
Make Seven Steps Second Nature . 57
Beyond the Box: Backup Resources . 58
Additional Backup . 58
Comparing Hard Drives . 63
Redundant Storage . 64
Take a Ride on Time Machine . 65
Backup Software . 67

part 2 Your Photos to Share

five Downloading Photos to Your Computer

Why You Should Know How to Download on Your Own 72
Disabling the Auto-Open Function in Photo Applications 74
How to Manually Download Photos to Your Mac or PC 77
No Double Downloading, Dig? . 80
Now, Format That Memory Card . 82
Beyond the Box: Card Readers, Memory Cards,
and Wireless Photo Transfer . 84
The Card Reader . 84
Quality Cards . 85
Wireless Transfer . 86

six Photos for Printing, Sharing, and Reference

Remember Not to Mess with Originals . 88
Selecting and Duplicating Your Best Shots . 90
Printing Your Photos . 92
Making Prints Last . 93
A Recipe for Your Printing . 96
Sharing Your Photos . 98
Keeping Shared Photos at Nice Specs . 98
Fear Not Sending Originals . 100
Reference Photos . 101
Beyond the Box: Online and Home Printing . 102

Online Printing . 103
Home Printing. 104

seven **Photos from Friends and Found Images**

Shared Photos . 108
Found Photos for Keeps . 110
Copyright, or Using Photos in a Public Way 112
Beyond the Box: A Few Points on Copyright. 113
Registering for Copyright . 113
How Long a Copyright Lasts . 114
Crediting Photographs . 116

eight **Conclusion**

part 3 **Some A, B, and Cs**

appendix A **What Time Is It?**

Horologists Love Time . 124
The 24-Hour Clock . 125
Daylight Saving Time. 126
Greenwich Mean Time and Coordinated Universal Time. 127
Time and Photography . 127
So Much More Than Hours and Minutes . 129

appendix B **File Formats**

JPEG (Joint Photographic Expert Group). 132
TIFFs (Tagged Image File Format) . 133
GIFs (Graphics Interchange Format) and PNGs
(Portable Network Graphics). 134
Raw Photos. 134
DNG (Digital Negative) . 136

appendix C **Metadata**

EXIF . 139
IPTC . 139
XMP . 141

Glossary . 143
Index . 150

introduction

This Guide Will Make Things Simple

I bet you got this book (or someone who likes you gave it to you) because your photos are important to you. Of course, they are! Your photos are your memories—not only for you, but to pass on to friends and future generations. You've probably learned the ins and outs of your digital camera and want to make sure that you'll enjoy the photos you take with it for years to come. This is where *The Digital Shoebox* comes in. Read on: In this book, you'll learn how to organize, find, and share your photos. It's easy!

Read on to find out how to organize, find, and share your photos!

Photography is a favorite pastime of mine as well as my business. Professionally, I've been the communications photography coordinator for the Academy of Motion Picture Arts and Sciences, keeping hundreds of thousands of digital photos in order as part of the Academy's historic photo archive. At the Academy, I discovered that organizing and archiving digital photos could be made simpler by setting up an organized workflow system and repeating it faithfully. Chapter 1, "Before You Take Photos," includes some of the most important (and most basic) steps to photo organization that I learned on the job at the Academy, such as setting your camera's clock and not resetting file numbering.

Nonprofessionally, I take hundreds of photos a month, both for fun and for the art of it. I found the need to organize at home, but I didn't want to implement the same professional level of software that I was used to in my work environment (and my computer wasn't quite powerful enough!). What I learned for simple methods of photo organization at home, based on standards I followed at work, is what *The Digital Shoebox* is all about.

The photos that you will find in this book were chosen for their balance of form and composition. In a book about organization and order, seeing balance seemed fitting. But, on a personal level, I love taking candid photos of my friends and family—a visual reportage of all social interactions. Over the years, I've noticed that my cohorts have gotten more and more used to having the camera around, and now everyone has one. Friends and family often either love mugging or simply go about their socializing with no mind for the camera—and the photojournalist in me, looking for that candid moment, rejoices. My collection of photos of friends, and especially family, is all-important to me. I'll always make sure that its care and organization matches that value.

Photos in the Old Days

Photo albums do lose photos sometimes.

How many photos do you have of yourself as a child? Perhaps this question makes you think of a particular shelf, drawer, or cabinet in your parents' or grandparents' house that holds a stack of musty old photo albums. You visit these albums occasionally—leafing through pages of fading photos in plastic sleeves or held in place by a film over a strange yellowing stickum that has long since dried up. You might come across an album page that has a photo missing. At some point, some sibling or cousin thought that this now-missing photo would do better in their possession than in this album. Or maybe you're the culprit. Do you remember where you put that photo you stole…er…removed?

It's so easy to take digital photos—you can take several thousand per year.

Kids today are going to have a completely different experience with family photos when they grow up with their parents' and grandparents' photo collections. And when I say completely, I mean majorly completely. First, if all the great photos that are taken of them were printed and put into photo albums, it would create a photo album collection that would not fit on any old shelf or cabinet, and certainly not in a drawer. After reading this book, you'll have a photo collection that's even safer than a stack of photo albums, because your photos will be organized, backed up, and easily navigable.

Second, you certainly don't need to print your photos to enjoy them (although printing is still a worthy thing to do with your photos—see Chapter 6, "Photos for Printing, Sharing, and Reference," for more on printing). There are blogs, Flickr, Facebook, MySpace, cell phones, e-mails, digital frames, and keychains with which to share your photos.

And with all of these virtual outlets for your photos, gone is the threat of stolen photos from the album. Even if almighty Facebook goes the way of the dodo bird, you'll still have your whole photo collection intact and in a safe place if you follow the advice in this book. Finding a photo file in a well-organized collection these days is more efficient and less expensive than digging up film negatives and getting them reprinted. Chapter 2, "Making a Home for Your Photos," will guide you to an organized system of filing to ease your photo search.

Why You Should Start Organizing Your Photos Now

It's simple. You should start organizing your photos now because soon you'll be looking back on *now* and it will seem like a long time ago (and think of all those photos that could've been in an organized collection by then)! Here's a cautionary tale: Fast-forward 10, or even just 5, years from now. Maybe your best friend is getting married and you want to contribute to the slide show, perhaps your girlfriend is having a big birthday and you need some great photos of her, or maybe

you just think one day, "Dang, I take a lot of photos—maybe I should get some of them together from the last 5 years and make them into one of those glossy photo books that you can get printed online."

Then you fire up your computer and realize that you have a big job ahead of you. Maybe you hadn't read this book and your photo-filing organization skills are terrible. Or maybe you forgot to back up your photos, and now some of them seem to have disappeared—gasp! (If you haven't backed up your photo files, see Chapter 4, "Preserving Your Photos Forever," ASAP!)

You can prevent this sense of overwhelming why-did-I-take-all-those-photos-if-I'm-never-going-to-see-them-again feeling by reading this book. For instance, Chapter 3, "Navigating a Sea of Photos," will enlighten you on the wonders of keeping a calendar to help you find photos.

This Book Is for You

This book is for all kinds of computer users.

This book is for people who take photos to enjoy their memories for the rest of their lives. It assumes that you have a pocket-sized camera, maybe even a digital single-lens reflex (DSLR) that's bigger than your pocket, or a cell phone that takes photos. Your photo files are JPEGs, you have a computer and maybe a photo printer, but you may not have Adobe Photoshop or Photoshop Elements or even want to bother with image-adjusting software. You want to enjoy your photo collection with a minimum of software applications. Chapter 5, "Downloading Photos to Your Computer," will tell you why the most basic, non-software-assisted way of downloading your photos is best. You like to share your photos with family and friends, and you receive lots of photos from them as well. Chapter 7, "Photos from Friends and Found Images," will tell you where to file those photos.

The seven steps in Part I will set you on the right track, and the discussions and instruction on sharing and using your photos in Part II will get you going. This book is meant to be

to the point. You'll get to the conclusion before you know it, and, by then, you'll sleep soundly at night knowing that your photos are safe and organized.

While you're reading, you'll find some informational asides along the way. Tips, reminders, and warnings are tidbits of information to beef up your photo-taking knowledge. "Food for Thought" sections will take you into a slightly advanced realm (or, in the case of Chapter 3, will tell you about nuns who keep journals). And if you're looking for direct resources for buying equipment and applications or you want to venture beyond the basics, you'll be pleased to find that each chapter ends with a section called "Beyond the Box" containing lists of resources and primers on more-advanced digital photo topics.

Dive into the appendixes for the ABCs of time, file formats, and metadata, and turn to the glossary to understand terms you might want to know.

By the way, if the nuances of your specific camera's functions don't seem to be covered by the directions in this guide, keep in mind that the most important instructions are the steps themselves. Please locate the manual for your camera if a function does not apply. A manual for your camera is most certainly available to download online from the manufacturer's Web site.

This book isn't geared toward a platform of Mac users or Windows users. It's for everyone. When necessary, instructions that differ between platforms are explained in Mac terms first and then in Windows terms.

And did I introduce you to Mr. Digishoe? He'll be your loyal companion to accompany you on an enlightening journey to digital photo organization!

Mr. Digishoe says, "Hi!"

part 1
Your Photos

one Before You Take Photos

It's a Brand New Day

You're about to clean up your photo-taking act with seven steps that will set you on the path to photo organization. (This chapter covers steps 1 through 3; Chapters 2 through 4 cover the remaining steps.)

If you bought this book while you were getting a new digital camera, great! If you already have a digital camera and you've been shooting for a while without doing much photo organizing, now is the time to start. When it comes to adopting good habits, better late than never!

Either way, before you take another photo, you'll perform three tasks:

1. Set your camera's internal clock.

2. Set your camera so that it doesn't reset filenames.

3. Make sure that you're shooting high-quality photos.

Like each of the steps in this book, these are not suggestions. You should definitely follow them, and you should do so as soon as possible.

STEP 1 Set Your Camera's Clock and Calendar

It sounds pretty basic, but setting your camera's internal clock is an extremely important step that many people neglect to do, causing unnecessary trouble with chronological sorting down the line. I know—I had to deal with this problem on a major scale.

My job in Los Angeles has been that of photo coordinator for the Academy of Motion Picture Arts and Sciences, presenter of the annual Academy Awards. This means organizing incoming photos as well as assigning photographers to Academy events. During my first year of heading up photo coordinating for the Academy Awards show in 2006, I had 10 photographers assigned to different parts of the red carpet, Kodak Theatre stage, and backstage. I worked with about half of these photographers throughout the year during other Academy events, and the

additional photographers were professional shooters hired just for the show. I'm pretty sure all of them had the experience of covering previous awards shows for longer than I had been working at the Academy. (In fact, I think a few had been covering the show for longer than I had been alive!) So, I was justifiably relying on their experience during the proceedings, and they were graciously keeping me from getting nervous about being the new gal in an old game.

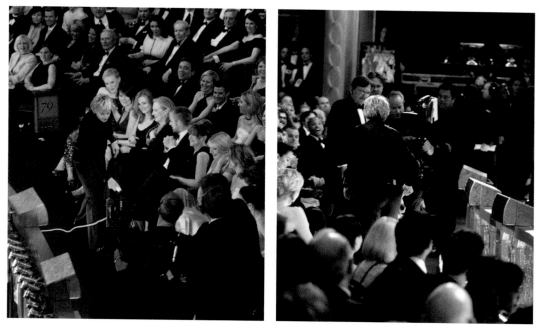

During a well-synchronized Oscars, it's easy to find two photos taken at the same time from different angles. Photos by Richard Harbaugh (left) and Greg Harbaugh (right). ©AMPAS.

Some of our photographers were more familiar with 35mm film than with digital. They were also instructed to cover the show with both mediums because these were still transitional days for the Academy in terms of digital images. The Academy library's archivists weren't ready to go whole hog on a new medium, but they knew backward and forward how to keep a negative pristine for ages. It was my job to handle the digital photos.

Well, as is always the case on the day of the show, it was so much fun I'm surprised I didn't faint. But we're talking a 21-hour workday here. This first year I forgot about time synchronization on the digital cameras. Some of my photographers remembered; some did not.

Then I tried to automatically organize sections of the show chronologically by browsing the hot-off-the-CMOS-sensor photos in the application Photo Mechanic. And, sadly, everything went quite awry.

REMINDER

Whoa! What's a CMOS Sensor?

A complementary meta-oxide semiconductor (CMOS) sensor is the image-capturing part of a DSLR camera (a DSLR being bigger than your pocket, probably, and with a single-lens reflex), as opposed to the typical charge-coupled device (CCD) sensor of a compact camera. Both the CMOS sensor and the CCD sensors are what pixels come alive on to make your pictures.

Michael was shooting from the center of the theater, and Richard was in the opera box, but to define who was shooting with the correct time, I would have to cross-reference with the shots that Darren was taking from backstage left. Oh, my! This would be confusing.

There are tools out there that can fix wonky time—so I knew that if I needed to, I could use an application such as Photo Mechanic or Expression Media to adjust, to the second, the in-camera capture time and date across multiple photos. But for the 20,000-plus photos that were taken on the day of the Academy Awards, I was better off sorting the show by photographer and working with time adjustments on an as-needed basis.

With event photography, the more shooting angles, the better.

$\boxed{\text{FOOD FOR THOUGHT}}$

Two Cameras, One Vacation, One Timeline

You're on a weeklong adventure to somewhere fun with your significant other—let's say Nuuk, Greenland. What's the first thing you should do after you pack that last pair of fleece mittens in your suitcase? Synchronize your camera with your adventure partner's camera. That way, you can consolidate all the best shots from both cameras and sort the photo files chronologically. (Be sure to consolidate duplicates of your original files. See "Remember Not to Mess with Originals" in Chapter 6, "Photos for Printing, Sharing, and Reference.")

You'll be able to see pictures of you dogsledding and then pictures of your partner dogsledding...you cross-country skiing and then your partner cross-country skiing. Rock climbing, helicopter rides, fjords, and glaciers—you name it, with synchronized photos, you'll have an adventure slide show featuring the best from both of your cameras that follows your itinerary step by step.

Keep in mind that if you both have the same kind of camera and there's even a slim chance of your photo files having the same filenames, you'll have to distinguish between the two sets by renaming one set to avoid photo files trying to overwrite each other. I recommend adding your initials to the beginning of the files by using an application that does batch file renaming. For inexpensive options (about $30 or less) for the Macintosh, you can download Renamer4Mac (*http://renamer4mac.com*) or A Better Finder Rename (*www.publicspace.net/ABetterFinderRename/*). For Windows, some cheap options are WildRename (*www.cylog.org/utilities/wildrename.jsp*) and RenameMaestro (*www.renamemaestro.com*). Or, if you have Adobe Photoshop Elements, it has a renaming tool (choose File > Process Multiple Files > Rename Files). So does Photo Mechanic (choose File > Rename Photos; then, in the Renaming String text box, put your initials followed by an underscore and the Photo Mechanic variable to autoenter the original filename, which is {filenamebase}).

To accomplish this as-needed time fixing, I would have to do some detective work. If only one photographer was shooting a particular area—say, guests in the theater lobby—determining the correct time was nearly impossible (unless

the photographer happened to catch someone's wristwatch clearly in the photo). For stage shots, which were being taken by up to five photographers simultaneously at any given time, I would look for photos of one moment in the show taken from more than two angles and then determine which two photographers were synchronized and go by that time. If none of them were synchronized, I would have to judge loosely at what point in the show the picture was taken and use that guess to set the time. With that guessed time adjustment, I would chronologically sort and tweak the time until the sync seemed to fall into place. What a project!

Try to keep things synchronized. You may not be taking photos with anyone but yourself, but think of yourself now, and think of yourself on a team with yourself 10 years from now, and you'll be happy that you shot things with the correct time.

How to Set the Date and Time

Follow these steps to set the date and time on your camera:

1. Turn on your camera, and find its settings by pressing a button labeled Set, Func./Set, Menu, or Home.

 Most cameras have a little camera, wrench, or toolbox as an icon in the menu items after you press Set, Func./ Set, Menu, or Home. Some cameras have a menu screen showing two or more tabs on the side or top with the camera icon, a wrench, or a toolbox icon, and perhaps a display icon. The camera icon usually indicates functions that have to do with how the photos will look and how the camera will take a photo, such as quality of the photo and focus area (**Figure 1.1**). If your camera has a manual setting, this can also include white balance, ISO, color effects, and other advanced settings. (See "Food For Thought: Using Manual Camera Settings" later in this chapter for more information.)

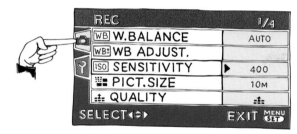

FIGURE 1.1 The camera icon menu usually lets you set the quality, focus area, and other functions related to taking a photo.

2. Use your arrow buttons to navigate to the wrench or toolbox tab.

The wrench or toolbox icon indicates functions that have to do with the camera itself, such as setting the internal clock and calendar, monitoring brightness, and setting whether the camera will beep or sound like an old-style camera when it takes a photo (**Figure 1.2**).

FIGURE 1.2 The wrench or toolbox icon menu usually lets you set your time and date as well as other utility functions.

Personally, I like my camera to be silent. Call me a purist, but if it doesn't have to make those sounds, why use them? It's like putting decorations on a cat!

Decorations on a cat may be amusing to some people. Photo by Paul Gachot.

I know, I know. Putting decorations on cats is pretty good fodder for photos. You bet—I've done it too.

3. Use the arrow buttons to navigate to the clock set function (**Figure 1.3**). You'll probably be using the up and down arrows to set the clock to the right time.

If you choose to use a 12-hour clock, make sure that you have your a.m. and p.m. set correctly.

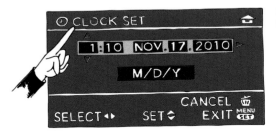

FIGURE 1.3 Setting the time and date on your camera.

4. Press the Set or Menu button to save the clock settings.

If you don't want to bother with a.m. and p.m., a 24-hour, international (also called *military time*) clock displays midnight as 00:00, noon as 12:00, and 6 p.m. as 18:00. See Appendix A for a stimulating discussion on how to find out what time it is (other than by consulting your cell phone's clock) and for loads more on time in general and time zones across the globe. I'm serious—check it out. It will remind you to set your camera's internal clock!

REMINDER

Set Your Home Time

If your camera has a World Time function, make sure that your Home setting is set to the right time zone. Some cameras have travel time settings, too, so that you can set your camera to a different time zone while maintaining your Home time setting. My Leica D-Lux has this function, and I can see how it would be very useful. If my Destination Time setting were set to the time zone covering the cities of Toronto, New York, Miami, and Lima, I could select that setting when I travel to Miami, Florida. Then my photos from the trip would have Miami time embedded in them instead of Los Angeles time, my Home time. But for my personal photos, I tend to ignore this perk and just treat my hometown time like my very own special GMT. (For more on Greenwich mean time, see Appendix A.)

The correct time in your camera is essential to your photos.

After your clock is set, remember to check on its accuracy every few weeks, especially when your camera battery runs out. This way, you will always be sure to be shooting with the right time and date.

(FOOD FOR THOUGHT)

Using Manual Camera Settings

Four settings that you might find under the camera icon when using the Manual setting are White Balance (WB), ISO, Metering mode, and Auto Focus (AF) mode.

White Balance (WB) helps the camera process color under different lighting conditions, eliminating strange color casts. Auto White Balance (AWB) means that your camera is judging on the fly whether it's in daylight, cloudy weather, indoor lamplight (tungsten), or fluorescent light. You can leave your camera on AWB and cross your fingers, or, if you have a manual setting and you know you're going to be taking photos at a picnic on a sunny day all day long, then you can set your WB to the little sun icon, as opposed to the cloud, lightbulb, or bar with lines radiating out of it (which represents fluorescent lighting).

ISO is the camera's sensitivity to light. As you increase the ISO from, say, 100 to 400, you get more bang for your light buck, which really means that your camera is working overtime to amplify the sensitivity to the light it's gathering to make an image. However, a higher ISO also creates more noise in the image (amplified graininess). This may not be apparent on a tiny LCD screen on the back of your camera, but it starts showing up as you view the image at a larger size. On my camera, I never shoot above a 400 ISO, because the images just fall apart into ugly noise. But top-end DSLRs like the Nikon D3 and the Canon EOS 5D Mark II can handle very high ISOs, such as 3200 and even 6400. These cameras tolerate very low light and still take good pictures. Here's to hoping that this technology trickles down very soon to cameras that don't happen to cost several thousands of dollars!

continues on next page

(FOOD FOR THOUGHT)

Using Manual Camera Settings *continued*

Metering mode is how you want the camera to juggle the other two light-related functions: f-stop and shutter speed. *F-stop* is the diameter of the hole that lets in light (the aperture), and *shutter speed* is how long that light has to go through that hole. The camera will proportionally use a small hole (high f-stop/small aperture) and a quick shutter speed (for example, 1/1000 of a second) in situations of extreme bright light. In a candlelit scenario, the camera will want to use a larger hole (low f-stop/large aperture) and a slow shutter (also producing more blurring if there is motion in the photo).

Confused? OK. Picture James Bond running through an explosives factory toward a large rolling gate that is slowly descending. How fast Bond runs (fast shutter) and how far the gate has descended (small aperture f-stop) are in direct proportion to how tightly you will be squeezing your date's hand in the movie theater (bright light).

James Bond runs very fast (shutter) if the explosives factory gate is very low (f-stop) in a tense scene (light).

If there is no tension in the scene (low light) and Bond is simply strolling (slow shutter) toward his lady friend standing outside of the nondescending gate (large aperture f-stop), the filmmakers might even use some slow motion (blurring) to make the scene more romantic.

OK, that was a stretch...but back to the point. Metering mode tells the camera to determine f-stop and shutter speed by (a) the whole scene in the frame, (b) just the center of the frame, or (c) a center-weighted account of the whole frame.

Auto Focus (AF) mode, in which the camera is focusing for you, works similarly to Metering mode, in that you can choose how the camera will determine focus. It does this by detecting multiple points in the frame and autofocusing on (a) the point it deems best, (b) just the center spot of the frame, or (c) a larger center area determined by you. Some cameras have face detection, too, which tells the camera to look for a face (or faces) in the frame and focus on that. Face detection in the camera does not mean that your camera will recognize people by name (yet!).

Good job. You're now enlightened on the importance of time. Just think of the millions of DVD players, coffee makers, and microwaves out there that are flashing "12:00" all day and night. People other than you seem to be programmed to ignore clock functions.

Now tell the people with whom you like to share photos to set their clocks too, so that you'll be synchronized. When taking photos with friends or family—think sync!

Think sync!

 ## STEP 2 · Don't Let Your Camera Reset File Numbers

Formatting the memory card in your camera (where your photos are stored) deletes all photos in your camera so that you can start taking a new batch of photos. If your file numbers reset during this process, they will roll back to zero. For instance, if you've taken photos IMG_0001.jpg to IMG_0345.jpg and then your camera resets file numbering after you format your memory card, the next photo you take will be IMG_0001.jpg again. You don't want this to happen.

Photo filenames should be as unique as snowflakes.

Setting file number reset to Off prevents a potential oversight that can lead to frustrating filing and future losses. If your file numbers reset to zero every time you format your memory card, you might eventually end up with 20 different photos called IMG_0001.jpg after 20 times of formatting. This would botch things up if you tried to consolidate some photos into one folder for a slide show or for a set of prints to be made. As mentioned in "Food For Thought: Two Cameras, One Vacation, One Timeline" earlier in this chapter, putting photo files with the same name together in one folder can get you into trouble. One photo might try to overwrite the other because they have the same name. As you probably know, computers cannot handle multiple files with the same name within single folders; the latest file will overwrite the earlier one with the same name. Every single photograph you take should have a distinct, ascending file number—as unique as a snowflake.

How to Turn Off File Number Reset

Follow these steps to turn off file number reset:

1. Navigate back to your wrench or toolbox settings by pressing Set, Func./Set, Menu, or Home on your camera.

2. Use the arrow buttons to find something akin to Number Reset or File Number Reset.

3. Select this option, and use the arrow buttons to select No or Off, as in "No thanks, please don't reset my file numbers" (**Figure 1.4**).

FIGURE 1.4
Make sure this says something negative, like No or Off. Don't take it personally....

STEP 3 If You Shoot JPEGs, Set Your Size and Quality to High

Steps 1 and 2, setting your camera's internal clock and turning off file number resetting, are the foundation for photo organization. They're two automatic features that will aid in future photo finding. Now you need to make sure that these photos have quality—on a digital level.

Please set your size and quality to high. Please? Large memory cards are cheap, hard drive prices are dropping as technology progresses, and viewing your photos at low-resolution and low-quality JPEG compression is emotionally crushing. Low-resolution, low-quality JPEGs may look fine on the LCD screen of your camera or even on a computer screen. But after you try to blow them up for printing, the fewer pixels and increased compression in these images show up as "jpeggyness," or visible pixelation.

For instance, if you have a 7-megapixel camera, it probably has a few settings for shooting photos at less than 7 megapixels in size. It also probably has a few settings of increasing compression to make your photos even smaller. Avoid both of these available settings. Your camera is just trying to be helpful by making it possible to create smaller photo files. But you can let your camera know that you appreciate its efforts and decline.

Low-quality shooting is like writing with only 19 letters of the alphabet at hand.

Shooting photos at the highest quality and resolution all around is like writing a sentence with all 26 letters of the alphabet as opposed to, say, 19. You can always use an image-editing or browsing application to downsize a copy of your original photo file later if you want to, by further compression or a reduced number of pixels (resolution). Reducing file size by saving with compression or lowering resolution is explained in "Keeping Shared Photos at Nice Specs" in Chapter 6.

I recommend shooting with the JPEG file format for your personal photo collection because it's the simplest format to use, compared to raw, TIFF, or other shooting formats. (See Appendix B for information on these and other file formats.)

How to Select High Quality and Greatest Resolution for Your Photos

Follow these steps to select the highest quality and resolution for your photos:

1. In your camera, go back to your settings by pressing Set, Func./Set, Menu, or Home.

2. Navigate to the tab that includes Quality and Picture Size (most likely the little camera icon tab).

3. Under the Quality and Picture Size options, use the arrow buttons to set these to the highest megapixels or finest quality possible (**Figure 1.5**).

If instead of High for quality there is just a series of grids containing increasing numbers of squares, choose the grid with the most squares. This represents Super Fine.

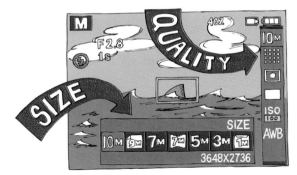

FIGURE 1.5 Maximum megapixels and Super Fine quality are the way to go.

My first digital camera was a gift, a Minolta DiMAGE. Before that, I had been a pretty die-hard film user. I loved my 35mm film Yashica T4 pocket camera, and I had been shooting with a 35mm film Nikkormat SLR since I was a kid. Anyway, I promptly (accidentally) left my DiMAGE in a restaurant and never saw it again, but by that time I was hooked on digital, so I went out and got a Casio Exilim, which was very slim and sleek.

I think memory cards were considered "big" at around 256 megabytes in those days (now you can get around 125 times that size at 32 gigabytes if you want), and I was excited about

how digital let me take lots of pictures for cheap. Logically, I figured I would set the photo quality to a medium level so that I could fit more on the card.

It's not "the more, the merrier" with photos when it comes to quality.

Then I went par 3 golfing with my old college friends Tim and Eric, who had just moved to Los Angeles to embark on strange and wonderful careers as comedians.

Eric is also a super-talented photographer, and he grabbed my camera to make sure that I, as the relative newbie digital photographer, had all my settings right. He immediately changed my resolution setting to High and my quality setting to Super Fine and explained that I had no choice in the matter but to leave them like that.

I subsequently had enough room on the card for about five more pictures of golf, because I had been taking lots of photos earlier in the day and had not emptied my card. But from then on, my photos were as high quality as they could possibly be. You can't say "What you don't know won't hurt you" about the quality of a photo, because you always do know. You were the one who saw what was in the frame with your own eyes, and, though cameras have not reached the megapixel and quality equivalent of the human eye, you'll be glad you kept your photos as close as possible in quality to what you saw. Think of the High quality setting as reading glasses for your camera that can capture the fine detail that might otherwise get lost.

I'm just going to say thank you to Eric right now, because that was the first, best advice I ever got on handling my digital camera. Thanks, Eric—great job!

Beyond the Box: Shopping for a Camera

If you're shopping for a new camera, that's very exciting! For not very much money, you can get a swell camera with enough megapixels and cool features to take great photos.

Buying a New Camera

The first three issues you'll want to consider as you start shopping are price, number of megapixels, and camera size.

Price

If you're on a budget, you'll be happy to know that you can find a camera for between $150 and $250 that will do you right. You may have a favorite brand, or your friends may have good advice on their favorite brands, but the most popular brands, such as Canon, Nikon, Panasonic, Samsung, and Sony, all have models that will not break your wallet.

Number of Megapixels

It may seem a bit confusing, but having more megapixels is not necessarily a good thing when you're dealing with a compact camera. When you pack more pixels on the small sensor of a small camera, the pixels also have to be smaller and, thus, compromise the light-gathering ability of the sensor. In short, think of it this way: If you owned a sailboat (representing your pixel sensor, which captures the image) and 24 dogs (representing pixels) that you loved to go sailing with, it would be much more comfortable to own a 150-foot yacht than a 12-foot skiff. In fact, with the yacht you could probably get 24 Irish wolfhounds on that boat pretty comfortably (representing big pixels with more color information). On the skiff, you should probably think about sticking to owning Chihuahuas (representing small pixels with less color information—nothing against Chihuahuas!). My opinion when it comes to cameras and compact CCD sensors is this: You'll be fine with 10 megapixels. More than that might be overkill.

Big dogs = big pixels.
Big boat = big sensor.

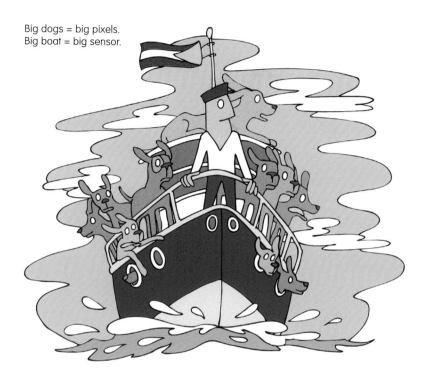

Camera Size

Do you want to carry your new camera around in your back pocket? Do you often carry a bag that could hold a slightly bigger camera? Or do you like to accessorize with a camera such as a DSLR around your neck? The main thing about a camera that's affected by its physical size is the size of the sensor (as just mentioned in "Number of Megapixels" and in the reminder "Whoa! What's a CMOS Sensor?"). More-compact cameras necessarily have CCD (smaller) sensors.

Comparing Features

You can check on all of these features across different brands on one of the most useful digital photo information Web sites, Digital Photography Review (*www.dpreview.com*).

Go there, select Buying Guide on the left, and try the side-by-side comparison or features search. Or, if you're a die-hard one-brand user, just use the site's camera database to see

what models are the most up to date. The site includes every camera under the sun with extremely up-to-date specifications for all models. The Web site also has forums, articles, glossaries, and tons of other useful information about all aspects of digital photography. ■

two

Making a Home for Your Photos

In Year and Month Folders

Even the most disorganized people have certain "filing systems" in their homes. They probably have a closet that holds stuff like coats and suitcases; they put their forks with the other forks in the kitchen drawer…no? OK, they at least have a dedicated silverware drawer or, um, section of their dish rack. They would not go looking for their coat in the silverware drawer, am I right?

Having dedicated places for certain items makes it easy to remember where to look for them when you need them. Even if you're the messiest kid on the block, you probably keep your toothbrush somewhere in the bathroom, right? (No? Aw, sheesh, just read on…).

Mr. Digishoe keeps his toothbrush close by at all times.

Repetition of a system can be quite pleasing.

Now I'll ask that you create a system for your photos that makes as much sense as any system that you have for other items in your house. The two steps that I cover in this chapter have to do with how and where you file your photos and the importance of original photo files. I'll also tell you a bit about some hazards to watch out for when you use image-browsing software to import and adjust your photos, as well as how to go about filing old photos.

Step 4 is very elegant. And it has to do with repetition. It's very simple.

STEP 4 File Your Photos by Year and Month

The most fundamental step you can take to make finding your photos easy is to set up a standardized filing system that you can repeat again and again. You may ask, "Well, but why can't I just file all the pictures that I took in Jamaica in a folder called Jamaica 2009 and then file all the photos of little Marly at preschool in a Marly Preschool folder?" And I will reply, "What if you meet someone named Jamaica and she becomes your best friend and you take photos of her in 2009, and what if, in the Marly Preschool folder, you also have some good photos of Marly and her friend Susan, so maybe there should be a Marly and Susan folder too?" Don't argue with me on this one.

There's No Wiggle Room Here

Some of these examples may seem unlikely, but basically, there is simply too much wiggle room and absence of standards when you start creating folders for your original photo files with random names all over the place. You may associate a group of photos with one thing when you download them, but 10 years down the line, you may associate that event with something completely different.

Let's just say that filing your photos by year and then by month will serve as the official headquarters of your personal photo collection.

Your year and month filing system will be the headquarters of your photo collection.

(FOOD FOR THOUGHT)

With Photo Organization, Repetition Is Your Friend

- Repetitive filing helps you remember how to organize your photos.

- I suggest that you repeat the way that you file your photos over and over and over again.

- It's really great to file your photos in the same way every time you download photos.

Am I being too repetitive?

A friend of mine recently told me that the word repetitive was first recorded in print in the year 1839—very appropriate to this step, because that happens to be the very year that Louis Daguerre announced that he had succeeded in perfecting a technique (later named for him) of making a positive photographic image on a treated metal plate.

How to File Your Photos by Year and Month

Follow these steps to file your photos by year and month:

1. Create a new folder named Photos on your computer: From the desktop, choose File > New Folder (Mac OS X) or File > New > Folder (Windows).

 Save the Photos folder inside the Users/Pictures (Mac) or My Pictures (Windows) folder that came with your computer.

2. Within that Photos folder, create a folder for the four-digit year, for example, 2009.

3. Within the year folder, create folders for each month, starting with the number of that month, for example, 01-January, 02-February, 03-March, 04-April, and so on (**Figure 2.1**).

4. Download your photos into the folder for the month in which they were taken.

For advice on how to download your photos, see Chapter 5, "Downloading Photos to Your Computer."

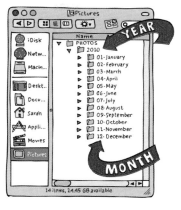

FIGURE 2.1 Create folders for each month of the year inside your year folder.

From now on, every time you download your photos to your computer, you'll be putting them into the corresponding month folder. The two-digit numbers for each month enable the list of months to stack up chronologically. (Use the main View menu to select a list display.)

You may be put off by the hyphens, but as a rule, it's good to get into the habit of avoiding any spaces in your names for files or folders. The Web doesn't always read spaces well when it comes to filenames. And though this doesn't apply to folders per se, using hyphens (or underscores) is simply a good habit to get into.

Tip: Organizing Photos from Multiple Cameras

If you shoot photos with more than one device, such as a camera and a camera phone, I find that it's handy to keep separate folders within the month folder to delineate between the two. For instance, inside the folder 03-March, make the folders 03-Camera and 03-Phone.

Retroactive Filing Galore

If you're feeling ambitious, you can even go back and file old photos by year and month after determining when they were taken (provided that the time and date was set correctly on your camera when you took the photos). The process is a simple matter of sorting your photos chronologically.

A photo from years ago. These birds found their home in the folder 2005/09-September.

How to Sort Your Photos Chronologically

On the Mac, follow these steps:

1. Make sure that you're in List view (View > As List) and that you can see the Date Modified and Date Created columns. If you don't see the Date Modified and Date Created columns, do the following:

 • Choose Finder > View, and choose Show View Options.

 • In the View Options dialog box, select the Date Modified and Date Created check boxes, and then close that dialog box (**Figure 2.2**).

 When you return to the Finder window, there will be a column that shows you when the files were modified (if ever) and when they were created.

2. Click the strip at the top of the column labeled Date Created to have the files line up chronologically.

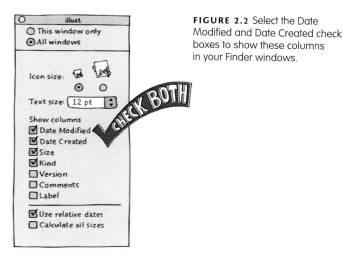

In Windows, follow these steps:

1. Choose My Computer from the Start menu. Then choose View > Arrange Icons By, and select Modified.

 To have this setting apply all the time, go to the Tools menu, select Folder Options, click the View tab, and select Apply View to All Folders.

2. After you can see creation dates for your old photos, you can then duplicate those photos to the appropriate year and month folders, as explained in step 5.

Tips: Duplicating Photo Files

I recommend duplicating your old files when filing them retroactively rather than moving them because filing by date does not work if you have ever used the Save As function on any of your old photos (which overwrites the original photo and treats it as a new photo). See "Step 5: Never Alter Original Files and Camera Filenames" that follows for how to avoid these kinds of shenanigans by always keeping your original photo files intact.

Retroactively filing photos can be laborious and time consuming. By leaving a copy of your original filing system intact, you'll at least always have that to return to should you come upon something wonky such as altered creation dates during the retroactive filing process.

How to File Photos Retroactively

Follow these steps to file photos retroactively:

1. After sorting your photos by creation date, select all the photo files from a particular month by dragging the selection marquee around them.

2. Press Command+C (Mac) or Ctrl+C (Windows) to copy the files.

3. Find and open (or create) the corresponding year and month folders for these photos.

4. Press Command+V (Mac) or Ctrl+V (Windows)—*v* for *voilà!* All of your photos to be filed retroactively now are duplicated in this folder.

Note: On the Topic of Command+V/Ctrl+V

The V doesn't really stand for voilà. I don't know what the V stands for, but it means paste, as in "copy and paste." I've heard various explanations—for instance, that it's for vaste, which is Russian for paste, or that it's just close to the C and the X, which are the other keys central to the copy-and-paste process.

But, Wait, Where Are My Photos?

You might not be sure where your photo files are because you did not file them yourself. (Instead, an image-ingesting and image-browsing application like iPhoto did.) Finding them so that you can file them by year and month might be a difficult task.

Did you file your photos? Or did an application file them for you?

Tip: How to Find Your iPhoto Photos on a Mac

iPhoto files your photos for you in your Pictures folder, within the iPhoto Library folder, in a folder called Originals. Later versions of iPhoto with the Leopard OS X make it even more labyrinthine and unintuitive to get to those photos. You have to hold down the Control key while clicking once on your iPhoto Library folder and then select Show Package Contents from the box that appears. This opens a new Finder window in which you can access the Originals folder.

When I first got a digital camera (my Minolta DiMAGE), I used iPhoto to import and browse through my photos and found its ease of use for viewing very handy. However, I discovered something deeply disturbing that caused iPhoto and me to have a totally huge falling out; I will forever, from now on, have a really hard time trusting its benefits.

I started to suspect that iPhoto had absolutely no regard for my computer's capabilities at the time. (Yeah, my computer was a little outdated, I'll admit, but keeping up with technology can sometimes be a little overwhelming, right?) iPhoto kept coming out with new versions, and I would dutifully perform the updates. Eventually, iPhoto started taking longer and longer to get started, chugging away on my computer, until eventually it just seemed to take forever before I could actually see my photos. The updated versions had begun to outrun the capabilities of my tired old operating system and slightly anemic RAM. It was time for me to divorce myself from the use of iPhoto.

Then, one day, a couple of friends came over for dinner and wanted to show some photos they had on their laptop. They selected them and opened them all at once using the application Preview. A lightbulb literally went on over my head (I think someone had turned on the light in the kitchen…). But really, I asked them if that's what they always did to browse through their photos, and they said yes, simple as that.

Preview can be a beacon of photo browsing. This, however, is Beavertail Lighthouse in Jamestown, Rhode Island.

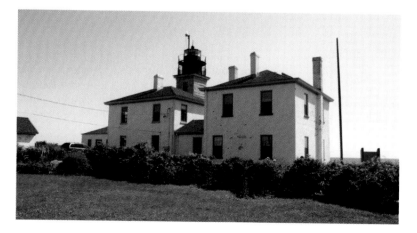

So, I tried that with my photos and found that, because I had imported my photos from my camera by using iPhoto, they had automatically been filed in the most annoying, obtuse way possible: by each...individual...day. That meant if I took photos every day of the year (and it was close to that), there would be 365 folders to open to access my photos. I couldn't just easily open all the photos I took on my trip to Rhode Island; I would have to open or expand one folder for each day at a time.

iPhoto, in the early days, was more of a problem than a solution.

I found this iStinkin' inefficient. I was starting to fear that I was stuck using iPhoto if I ever wanted to see those photos again. So, you see, one of the goals of this book is to send you into the future, free of major annoyances like this that may be forced upon you by some applications.

Tips: Fixing Funky Filing

There is a way to remedy the iPhoto filing structure situation. What I did was to use an application called Expression Media. I imported all of my photos from my iPhoto Library/Originals folder into what is called an Expression Media catalog so that I could browse every single photo at once, despite them being located in a million folders. Then, using Expression Media, I exported them to a single folder.

You can also use iPhoto to undo its own quirky filing system. Simply select your entire photo library, and choose File > Export. Then under the File Export option, send them to a specific folder as Full-Size Images or Originals. You'll have your entire photo library in one place as individual files. Keep in mind that if you have a couple of thousand photos in your library, this process could take a few hours.

Now that you know where your photo files are, step 5 will explain what *not* to do with them.

<table>
<tr><td>STEP
5</td><td># Never Alter Original Files and Camera Filenames</td></tr>
</table>

Of course, you will be doing things with your photos, such as resizing for e-mailing or for posting on a Facebook page or applying effects or enhancements to your heart's content. But you will be doing these alterations to a duplicate of the original file created by your camera, and you will file that duplicate somewhere else.

Warning: Don't Tamper with Your Original Files!
The originals are your master files. Simply leave them alone.

Think of it this way—the files that are filed in your month folders are sacred, and you want to keep your filing system of these master files as simple and untouched as possible.

So, let's just leave it at that. After your photos are filed, leave 'em be, and don't touch 'em—duplicate 'em!

(FOOD FOR THOUGHT)

Image Editing in Image-Browsing Software

If you ever use software to browse your photos and it lets you make adjustments such as cropping and color changes, make sure that the browsing software is not actually altering your original photos.

This may seem crazy, I know. You can see the photo, and you can see it being altered—why wouldn't that alteration be happening to the original photo? But think of it this way: When you make adjustments to your photos by using software such as current versions of iPhoto, Adobe Photoshop Lightroom, or Aperture, these visual adjustments happen within the world of the software, outside the actual pixels of your photo. The software tells your photos about the adjustments, but it doesn't actually force the changes onto your photo files right away.

If, however, you export a photo from the software with accompanying adjustment information, the software will marry the two and create a new photo that looks exactly like the adjusted image that you saw in the software. You can also manually tell the software to, indeed, write the adjustment information directly to the photos if you want.

In other words, with applications such as iPhoto, Lightroom, and Aperture, the cropping, color enhancing, lightening, and darkening that you do is just an illusion until you decide to make it real.

How to Duplicate Your Photos

Follow these steps to duplicate your photos:

1. Select the photo files you want to duplicate.

 You can use whatever selection technique you're comfortable with—drag a selection marquee around the photos, and press Command+A (Mac) or Ctrl+A (Windows) to select all photos. Or Command-click (Mac) or Ctrl-click (Windows) the individual photos you want to select.

2. Press Command+C (Mac) or Ctrl+C (Windows) to copy the files.

3. Press Command+V (Mac) or Ctrl+V (Windows) to duplicate the files in a new folder.

For details on where to file your duplicates, see "Selecting and Duplicating Your Best Shots" in Chapter 6, "Photos for Printing, Sharing, and Reference."

I duplicated this photo of my mother's cat, filed it, and then e-mailed her the copy.

Now that you've made a home for your photos, the next chapter will give you the grand tour and show you the way around that home.

Beyond the Box: Where to File Movies

There's probably one more thing that your camera does along with its picture-taking abilities (other than look good in front of your face), and this is that it makes movies. I suggest you file your movie files just like your photos but in a separate folder from your Photos folder called Movies, and I suggest, within that Movies folder, that you keep them organized by year and by month. This means you'll be picking them out of your regular photo files as you download photos to your computer. There's an easy way to sort your different file types in separate folders so that you can find your movies all at once.

Here's how to file your movies:

1. Make sure that you're in List view and that you can see the Kind column in your Finder (Mac) or the Type column in My Computer (Windows).

 If you don't see this column, on the Mac, open a Finder window in List view, choose View > Show View Options, and select the Kind check box; or in Windows, choose View > Arrange Icons By, and select Type.

2. On the Mac, find the Kind column, and click its title bar. (In Windows, the files will already be sorted by type.)

3. Scroll up or down to find your movie files. They'll have an extension that is something other than .jpg—probably .avi or .mov.

4. Select all these movie files by clicking the first one, holding down the Shift key, and then clicking the last one once (or just click and drag around the lot of them).

5. Drag the selected movie files to the month folder that you created for them.

Do you want a cheap way to edit these little movies together? You can try playing around with iMovie on your Mac, but an inexpensive (about $30) and simple alternative is QuickTime Pro from the Apple Store online, which allows very basic editing of your movie clips. ■

Makin' movies with a digital camera is like making movies for real, really.

three

Navigating a Sea of Photos

Ahoy! Thar Be the Photos!

Now that you've made a comfy home for your photos within the year and month folders, you'll always be able to find those photos you took of your daughter when she was Sharpay from *High School Musical* for Halloween, complete with diva microphone headpiece (a must-have accessory) and formal dress. All you have to do is remember how old she was to locate the year in which to browse your 10-October folder.

On the other hand, if you sometimes feel like your mind is made of Swiss cheese and you don't have a clue exactly when the barbeque was at which you took photos of your dad on the trampoline, but you need those shots ASAP for his 60th birthday party slide show, at least you'll know to start looking in the summer months—maybe even May or July, because those months have Memorial Day and July 4th, two of the most barbeque-friendly holidays.

If you have a photo like this of your dad, it will look great in a slide show.

However, something else will assist you in finding your photos—a secret weapon that has nothing to do with your camera. It takes a bit of diligence, but it's also useful in ways that extend far beyond your personal photo collection. In this chapter, I'm going to convince you to keep a personal calendar.

STEP 6 Keep a Calendar

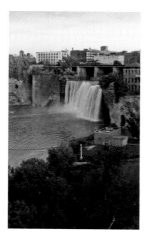

My calendar reminds me that I visited Rochester, New York, in September of 2009. To find photos from that visit, such as this picture of the Upper Falls of the Genesee River, I'll look in that month folder.

A digital, online, or old-fashioned paper calendar can be extremely helpful in finding your photos. It's all tied in to filing your photos by year and month. Personal photographs are a visual diary of your life, and just as your visual diary will help you enjoy your memories, your calendar will help you locate those visual cues.

You might already use a digital calendar that came with your mail application, such as Microsoft Entourage or Outlook Express, or perhaps you use iCal, which comes with all Macs (iCal is now part of Apple's online MobileMe service as well at *www.me.com*). Or perhaps you dig the Google or Yahoo online calendars for their free-account holders (*http://calendar.google. com* and *http://calendar.yahoo.com*). It doesn't matter what kind of calendar you use. What's important is that you have one and that you put stuff in it. This stuff includes notes about your get-togethers with friends, where you were on holidays, birthdays, movies you saw, even your regular everyday activities. All of these notes will be the breadcrumbs that lead you back to photo memories.

I keep a few iCal calendars within the iCal application for work and personal use (File > New Calendar). In applications such as Microsoft Entourage, a similar separation of calendar uses can be done with categories (File > New > Calendar Event and, from the event window, Categories > Assign Category). I also enjoy keeping a handwritten calendar. These different types of calendars serve two functions for me. I record events in the handwritten calendar after they've happened, like a diary (and sometimes like a quiz, when I have a hard time remembering what happened even yesterday…), and I use iCal to note appointments and plans in the future so I don't forget them. I usually turn to iCal when I need help remembering when something happened, because it has a search box for locating terms that you enter.

Searching my calendar for a trip to Joshua Tree National Park led me to finding this photo from the trip.

Journals Are Good for Your Brain

If you keep even more than a calendar—if you keep a daily written journal or diary (kudos! It goes really well with your visual photo diary), keep in mind that the more details and complexity that you express in your writing, the more terrific it is for your brain—like Sudoku and crossword puzzles. This is what Dr. David A. Snowden, a professor in the Department of Neurology and Sanders-Brown Center on Aging at the University of Kentucky determined during something called the Nun Study in the '90s.

The study focused on a community of nuns from which Dr. Snowden and his colleagues hoped to learn more about aging and Alzheimer's disease. A group of the nuns had written autobiographies in their 20s, and Dr. Snowden and his colleagues found that those who showed a higher "idea density" in their sentences showed fewer signs of dementia and Alzheimer's disease as they aged. Higher "idea density" meant that they would be more likely to write, "I walked briskly to the store but tried not to skip, and I was happy to be wearing bouncy sneakers and enjoying the sunny day specked by small, fluffy clouds," rather than, "Went to store today." (I made that up—none of the nuns wrote that—but it is indeed a sentence that shows high "idea density.") So, elaborate! Jog that brain! It's good for you.

A No-Brainer Way to Browse

All right, enough of this talk about trying to remember things and making your brain stronger—let's get back to simple. You want to find photos of your cousin who visited last year. You reference your calendar and find out that she visited in May. Now you need a way to view the photos in that month. Some applications simply give you a way to look at photos and do little else. I'm going to suggest that you use these simple photo viewer applications as the most straightforward way to browse.

You might not even think of your photo viewer as an application, but when someone emails you a photo and you click the file to see it, what fires up and lets you see the photo is probably Preview (Mac), Windows Picture and Fax Viewer (Windows XP), or Windows Photo Gallery (Windows Vista). As I mentioned in Chapter 2, "Making a Home for Your Photos," I was tickled when I realized that I could view all my photos from a particular month at once by using Preview.

First, you might want to make sure that Preview (Mac) or one of your Windows photo viewers is indeed your default viewer before selecting and clicking to open a whole month of photo files. You can make your computer use the application of your choice every time you open JPEG images.

How to Set a Default Application to Browse Photos

Follow these steps to change the default preview application on a Mac:

1. Click one of your photo files and press Command+I. (I is for info.) A box pops open with a lot of information about that particular file. One of the lines of information will have an arrow pointing to Open With.

2. Click this Open With arrow (if it is not already expanded) to see a pop-up menu with available software applications.

3. Choose Preview. If Preview is not in the list, choose Other, and navigate to Preview in your Applications folder.

4. Then click the Change All button under the text "Use this application to open all documents like this."

The first time you open a particular type of file in Windows, it will ask you which application you want to use and whether you would like to continue opening that file type with that application. If a default has already been set, you can change it.

Follow these steps to change the default preview application in Windows XP:

1. Run Windows Picture and Fax Viewer by choosing Start > All Programs > Windows Picture and Fax Viewer.

2. Choose Tools > Options > File Types.

3. Select .jpg to set Windows Picture and Fax Viewer as the default application.

Follow these steps to change the default preview application in Windows Vista:

1. Choose Start > Control Panel > Default Programs > Set Your Default Programs.

2. Select .jpg for the file type.

3. Click Change Program.

4. Select the Windows Photo Gallery.

Now you're ready to do some browsing, as described in the steps that follow.

How to Browse a Month of Photos

Follow these steps to browse a month of photos:

1. On your computer, open the month folder.

2. Select all the files by clicking and dragging the selection marquee around them or by pressing Command+A (Mac) or Ctrl+A (Windows). A is for all.

3. Double-click any of the files to open and preview them.

On a Macintosh, Preview will open one big view window showing the first photo and a strip of photos on the side for navigating

(**Figure 3.1**). Use the arrow keys on your keyboard to move from one photo to the next, or click individual thumbnails on the side to get to a particular photo.

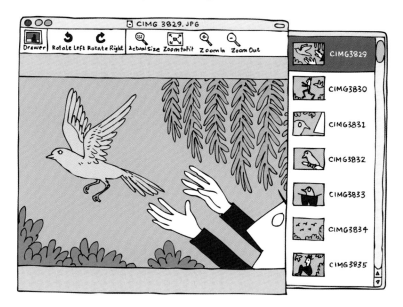

Macs with Mac OS X Leopard and beyond also have a Quick Look function. After you've selected all of your files to browse, click the eye icon at the top of the Finder window (**Figure 3.2**), or choose File > Quick Look. Or just press Command+Y. This is a quick and handy way to look at your photos.

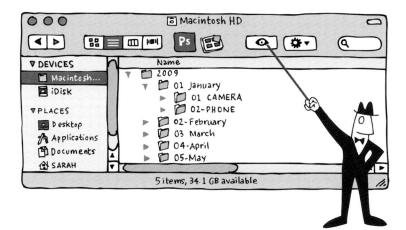

In Windows, Windows Photo Gallery will show you thumbnails of all your files in your month folder and, if you click one, a large view of that photo (**Figure 3.3**). You can use the arrow buttons to navigate between photos.

FIGURE 3.3 Windows Photo Gallery gives you a nice large view of each photo.

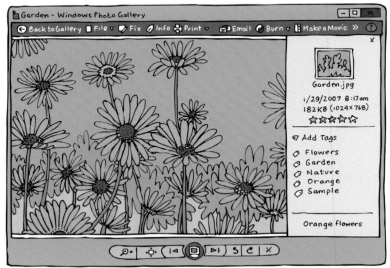

Six Steps Down, One to Go

Six steps down, one to go.

You're on your way: You've learned how to set the correct time, preserve the camera file numbers, and maintain quality for JPEG photos; and you've learned about filing by year and month, preserving your original files, and keeping a calendar. Those are the first six steps to a safe and secure personal photo collection.

In Chapter 4, "Preserving Your Photos Forever," I explain the most important step of all—step 7 is all about backing up your collection. Sounds like something complicated that you've been "forgetting" to do? I'll make it easy!

But first, some more-advanced techniques for navigating photos.

Beyond the Box:
Pro Navigating Techniques

Would you like to navigate your photos like an America's Cup captain? Are you ready and willing to lay down some clams for some serious image-browsing software? Is your photo collection as deep as the high seas? Do you want to yell things like "Raise the mainsail!" "Ready about!" and "Hard alee!"

Ahoy! That's a big boat.

Actually, ignore that last question. But if you answered yes to any of the other three, read on. I'm going to tell you about a few professional solutions for photo collection navigation.

Professional Image-Browsing Software

Across the spectrum of image-browsing software, where good and cheap means free and where robust and expensive means hundreds of dollars, you have many options and features to choose from. Previously in this chapter, I advised you to learn how to use the simplest image-browsing software, Preview, Windows Picture and Fax Viewer, and Windows Photo Gallery, so that you have that knowledge as your base. If you live by the principle of Occam's razor (all things being equal, the simplest solution is probably the best), then you should follow that advice.

But, full disclosure here: I use professional image-browsing software. And I like it. I use Photo Mechanic like it's going out

of style, and I think Expression Media is tops. I also really like Adobe Photoshop Lightroom.

My two cents is that there are two reasons to use professional-grade image-browsing software:

- You want to create a cataloging system for your photos, in which you can browse through your photos by terms that are defined by you (keywords, which are described in the next section; categories; ratings; and the like) or your camera (time, camera model, f-stop, and so on).

- You want to be able to adjust your photos while you're browsing (without having to run Adobe Photoshop or other dedicated image-editing applications).

There are a lot more perks to be found across applications that make up the image-browsing spectrum, but I consider these two reasons to be first and foremost what might prompt you to take the time to learn them or to hand over your credit card information to make such an investment.

In a nutshell, your basic image-browsing applications are iPhoto (free, Mac-only), Picasa (free, for the Mac and Windows), and ACDSee (about $50, Windows-only). With these you can browse and rate photos, add keywords, make minor nondestructive image adjustments, and even print or post images on the Web. (See "But, Wait, Where Are My Photos?" in Chapter 2 for more about iPhoto.)

More-advanced and pricier applications are Aperture (about $200, Mac-only); Adobe Bridge (part of Photoshop, about $700), Photoshop Lightroom (about $300), and Expression Media (about $200)—all available for both the Macintosh and Windows; and ACDSee Pro (about $130, Windows-only). These offer all the previously mentioned capabilities and a little more oomph.

You can use Photoshop Lightroom and Expression Media to create catalogs for your photo libraries. These applications are designed for people who use the internal information, or *metadata*, of the photo files, such as file description, keywords, locations, photographer information, and copyright, on a regular basis to manage their photos' organization and

add value to their collection (because if you can't make sense of a collection, it's not worth much). This metadata is stored inside the file header (for JPEGs). Parts of it (such as copyright) are editable, and other parts (such as resolution) tend to be locked. For the ins and outs of metadata, see Appendix C.

Then there is sweet little Photo Mechanic. Photo Mechanic is a relatively inexpensive ($150), very elegant photo-browsing application that was developed for photojournalists. It doesn't have any image-adjusting capabilities, but it's really great for importing photos, browsing, rating, making contact sheets, and editing IPTC information (which includes the metadata file description, keywords, locations, photographer information, and copyright categories mentioned earlier).

There are many more browsing applications, including ones that probably came on a CD with your camera. But those I've listed are what I consider the most likely candidates to give a whirl.

Keywords—Tag! Your Photo Is It

A keyword, or *tag*, is a word that you add to metadata information embedded in your photo by using an application such as those mentioned in the previous section. You can add many keywords to one photo, and when many photos have the same keyword, you can automatically group those images together by using image-browsing software to search for that keyword.

Keywords for this photo might include *boat, inflatable, motorboat, dinghy,* or *crowded.*

Honestly, I have mixed feelings about keywords. I think they work well in conjunction with categories you can set in a collection catalog in such applications as Expression Media and Photoshop Lightroom. With categories, you can group photos by subjects that are nested, whereas keywords are not nested. I might tag a close-up photo of bees with the keywords *bee*, *insect*, and *furry*, but I would also put all my bees in a category called Bees and file that within a category called Insects (**Figure 3.4**). I find that objective words (like *Bees* and *Insects*) make for good categories as well as keywords, but subjective (or descriptive) words (like *furry*) should be kept as keywords only because they apply across objective word categories. As you might imagine, categorizing or keywording can become a personal preference.

FIGURE 3.4 A photo of furry bees that is filed in the Bees/Insects categories and is tagged *bee, insect, furry.*

PHOTO BY PAUL GACHOT

With cataloging software such as Expression Media and Photoshop Lightroom, you can assign a category to a particular image without actually moving the original file. In Chapter 6, "Photos for Printing, Sharing, and Reference," I suggest that you do something similar, but with duplicates of your photos that you want to group in a logical way.

Printing Contact Sheets

Contact sheets provide a way to browse thumbnails in hard copy. In film photography, professional photographers traditionally shoot a roll of film, develop it, and then lay the negatives directly on a piece of 8 x 10 photo paper to expose a *contact sheet* of the images. In browsing the negative-sized images through a magnifying glass, or a *loupe*, they determine which images they want to enlarge for printing.

Though *contact* is not technically the correct word to describe this process in the digital photography world, many photo applications have a way to approximate this and call it thusly. Photo Mechanic has a Contact Sheets tab when you select multiple frames to print. Photoshop CS3 has a Contact Sheet II option under File > Automate, and in Adobe Photoshop Elements, the Contact Sheet II option is directly under the File menu. Photoshop CS4 requires that you use Adobe Bridge CS4 to create and save contact sheets in PDF form. In Bridge, using the Output Module, select PDF and under Template choose either 4 * 5 Contact Sheet or 5 * 8 Contact Sheet. Later versions of Preview, post–version 4, also have the ability to print multiple images to a page within the Print options.

Tip: Don't Forget to Include Filenames
With contact sheets, an original filename automatically printed under each thumbnail will give you a way to find the original photo. Some image browsers, such as Preview, do not give you this option.

And if you're wondering whether this is really useful or just a waste of paper, you aren't off-track—film photographers now typically digitize their negatives and upload to online photo-hosting services such as PhotoShelter, liveBooks, or ExposureManager, thus taking their "contact" sheets online. Whether photos originate on digital or film, pro photographers can use these online photo-hosting services to offer clients password-protected access to their work. Professional online hosting is generally customizable by the photographer in terms of the look and feel of presentation and services offered

to clients (browsing images, buying prints, and downloading photo files). In comparison, most free photo-sharing sites such as Flickr, SmugMug, and Photobucket are somewhat one size fits all. (All of these photo-hosting Web sites are discussed in Chapter 6.)

However, some people simply prefer to hold something in their hands when they browse photos. Printing contact sheets covering all of the photos in each of your month folders and filing them into binders is not a bad habit to get into. Sometimes it's easier to go to a shelf and page through sheets of images rather than fire up a computer and hard drive. ■

Some photographers still like to work with contact sheets.

four

Preserving Your Photos Forever

Back Up Your Junk

Undoubtedly, someone has advised you to back up your computer. If it hasn't been suggested by someone who cares about your well-being and sanity, then you probably read about it in an advice column, in a magazine, or on a Web site or blog, or you heard about it on a news program. Worse, it was suggested to you the last time one of your hard drives fizzled like bacon on a griddle and you lost everything.

Fried hard drives are bad for your health.

I know how it is. It's exciting, and relatively expensive, to get a new computer. In terms of speed and hard drive space, you probably shop for as much as you can afford. One hundred and sixty gigabytes (GB) of internal hard drive space seems like a lot, and you probably say you'll get that extra external hard drive to back up everything "soon, real soon." You may have tried it before and found the whole process confusing and awkward. Did you back that up already? Are you going to overwrite something that isn't backed up?

I advise that you learn to use automatic backup software, because it will let you stop worrying and love your backup system. There are a lot of backup software options out there. Take a look at "Backup Software" later in this chapter for some help.

In this chapter, I'll give you one recipe for a simple way to back up your photos. You can choose to follow the recipe, do the research on a system of your own, or take advice from your local computer consultant on backup solutions. But the most important message of this chapter is do it—and make it as easy as possible for yourself so that it'll actually get done.

STEP 7 Back Up Your Photos

Here's your goal: to have a master version of your photo collection (originals) and an identical backup copy of your photo collection. First, I'm going to advise you on how to set up the master version. Second, I'll give you the recipe for one system of creating a backup copy. For this recipe, I advise that you dedicate one computer to downloading your photos (as opposed to, say, a laptop and a desktop computer that you use interchangeably), and I assume that you're following all of the other steps in this book.

The Master Version of Your Photos

To determine where to keep the folder containing the master version of your photo collection, here's a rule of thumb: If you have a pretty heftily sized internal hard drive in your computer (320GB or more), you can probably comfortably keep your entire photo collection (the originals) on that machine. However, if your computer has a hard drive smaller than 320GB, I recommend that you dedicate an external hard drive, 320GB or more, to be the home of the master version of your photo collection. There are plenty of other things like music and movies that probably will occupy lots of space on your computer's hard drive.

REMINDER
Hard Drive Shopping

When you shop for external hard drives, look for as many giga-bytes as you can afford while keeping in mind that external hard drives are getting bigger and cheaper all the time. If you run out of space on your hard drive holding the master version of your photos, I recommend that you transfer the entire collection to a newer and bigger hard drive with plenty of space for growth. Remember floppy disks? What if you had put your photos on floppy disks and just kept filling new floppies as you ran out of space? Upgrading the hard drive on which you keep your entire master collection every once in a while is a good idea.

A Recipe for Backup

Here is one recipe for backing up a computer with less than 320GB of internal hard drive space:

- One computer with an internal 80GB to 160GB hard drive. Make a Photos-Download folder with the year and month structure in your Pictures folder (on the Macintosh, choose User > Pictures; in Windows, choose My Computer > Pictures).

- One 500GB hard drive (hard drive 1; cost: about $160) connected via FireWire or USB 2.0 (more common for Windows users) to your computer. This is where your master version will live in a Photos1 folder.

- Another hard drive like the one just mentioned in the previous paragraph (hard drive 2), either connected via FireWire to hard drive 1 (hard drive–to–hard drive connecting is called *daisy chaining*) or plugged into an additional USB port on your computer. (If you run out of ports, you can purchase a powered USB hub that will give four more ports for about $30.) This is where your backup copy will live in a Photos2 folder.

- Automatic backup software on your computer (cost: about $30).

For recommendations on hard drives and automatic backup software for Macs and PCs, see the respective sections in "Beyond the Box" at the end of this chapter.

Now mix!

How to Back Up Your Photos

Follow these steps to back up your photos:

1. Download your photos from your camera to the Photos-Download folder and its year and month filing structure.

2. Select all new photos that you just downloaded, and drag them to the corresponding month in hard drive 1. (See "No Double Downloading, Dig?" in Chapter 5, "Downloading Photos to Your Computer," for how to do this.)

3. Set your backup software to automatically target your Photos1 folder to send new photos to the Photos2 folder on hard drive 2.

4. Run your backup software.

I like this photo. I think I'll make sure it's *backed up*!

And now you're saying, "Wait! Hold on a minute here! The fourth step is 'Run your backup software'? What kind of recipe instruction is that? That's like giving me some flour, cheese, and an oven and telling me to go soufflé my soufflé!" But what's important here is that you understand how backup software works. In using backup software, you're having the software look at what you have in one place (your photos in the Photos1 folder) and compare it to what you have in a second place (your photos in your Photos2 folder) and fill in any gaps that the software finds in the second place to match the first. You'll need to learn how to set up the parameters on whichever backup software you choose to use.

Sometimes it's the theory behind a system, not the system itself, that will get you started in the right direction.

There are a few ways to cook this egg. For the purposes of the preceding recipe, you're looking for backup from a first target folder to a second target folder, sometimes called *left-to-right backup* (not bidirectional or blind backup). In other words, you want the software to look at the first target, check in with the second target, and make any additions to the second target to make it just like the first.

> FOOD FOR THOUGHT
>
> ## What Makes This Automated
>
> You may ask, "If I'm the one to run my backup software to send photos to hard drive 2 every time I want to back up, what makes that automatic?" Good question! You can set automatic backup software to run on its own on a schedule if you want. But in this particular example, what makes it automatic is that the software is performing the same procedure every time—you set it to transfer only new photos to hard drive 2, thus leaving little room for error. Also, having the software complete this process doesn't take as long as figuring out for yourself which photos are new between your master and backup copies.

Purging Photos from Your Photos-Download Folder

After the master version of your photos is on an external hard drive (hard drive 1), you can consider the photos that you download into your Photos-Download folder expendable. You have your master and backup copies of your photos on hard drives 1 and 2; therefore, you can delete photos from your computer's Photos-Download folder if your computer's internal hard drive space is reaching capacity.

Warning: Buffer Your Hard Drive Space

Always leave a buffer of 10GB to 20GB of empty space on any hard drive, internal or external. Your software and file processing needs this empty space to operate in a speedy fashion.

When You're On the Go

Of course, if you own a laptop, you'll want to carry it around and take it with you when you travel. For convenience's sake, you may not want to carry your external hard drives with

you. But I'm betting you will want to share your photos with friends when you're on the go. So, what do you know? You'll have all of your most recent photos on your laptop in your Photos-Download folder. These can be your show-and-tell photos, while your master version and backup copies stay safe at home.

If you're on the go with a laptop but without a backup drive, you can still make sure you have your photos in two places at all times. Simply don't format your memory card if it has photos on it that haven't been transferred to your master collection and backed up at least once. If you think you'll be taking more than a few hundred photos, this will mean you should carry a few gigabytes of memory cards. (Or just one card that has lots and lots of gigabytes.)

And now, I have to tell you a story that conveniently (if you can call it that...) happened just before I sat down to write this chapter.

(REMINDER)

Hard Drives Out and About

Some external hard drives are designated as portable. They're small and easy to carry around, which is great. But if you're like me and you tend to drop things or make sudden moves that might inadvertently disconnect your drive, you may be better off leaving them at home safely placed on your desk. If you do travel with a hard drive, just keep in mind that hard drives have spinning parts inside of them that don't like hard knocks, especially when they're connected to your computer and running. Try not to move them while they're connected, always wait at least 10 seconds before moving them after they're unmounted from your computer, and watch the butter fingers. Also, consider getting a mobile model that is designed to be extra tough, like the LaCie Rugged Hard Disk (cost: about $110 for 320GB, USB 2.0; or $160 for 320GB, FireWire 800, FireWire 400, and USB 2.0).

Murphy's Law in Action

Computer malfunction =
a horrible, sinking feeling.

As if on cue, I was preparing my breakfast and about to sit down to get to work on polishing off this chapter when I heard an alarming exclamation (that I will spare you) coming from the living room. I rushed in to find that the love of my life, Paul, had just accidentally tipped his coffee over onto my laptop. Needless to say, there was a flurry of paper towels and rags and "Sorry! Sorry!" coming from him. Luckily, the laptop was not open for the spill, and after a few minutes we seemed to have most of the coffee sopped up. I switched the laptop on, and everything seemed fine…until the little arrow cursor stopped responding to my finger on the trackpad. Work came to a screeching halt.

Anyway, the computer is now partially disassembled (battery, RAM, and internal hard drive taken out) and has been sitting in the sun for 2 hours and 14 minutes in the hopes that any moisture that seeped into the cracks will simply evaporate and stop causing problems. I'm now writing on Paul's laptop and feeling hopefully optimistic about the fact that I live in a sunny town, but we'll see what happens.

Warning: Common-Sense Computer No-No
By the way, I really don't recommend disassembling your computer. It's probably best to take it to the computer shop quickly if something like this happens, which I will promptly be doing if things are still wonky when I try to put mine back together. (Note the word try *in that sentence.)*

But, hey! Look! I'm still working on this chapter, and I still have all the other work I've done on this book at my fingertips even though my computer is separated from its internal hard drive and sitting out there in the sun like a sunbathing beauty. You know why? Because last night, before I went to bed, I made sure all of my work efforts, as well as the new photos that I downloaded from my camera yesterday, were backed up.

Yay! I still have this picture I took of a beach sunset two days ago.

So, I suppose I have to thank Paul for unwittingly, and in a timely manner, supplying the material for a scarily pertinent anecdote for this chapter about computer backup.

Follow my advice on backup so that the next time you spill something on your computer (or suffer a power surge, drop your computer, buy a faulty hard drive that malfunctions, or have an unfortunate encounter with an extra big magnet…) you will not lose your precious photos.

Make Seven Steps Second Nature

So, those are the seven steps to managing your digital shoe-box! Not so bad, eh? And the longer you follow these steps, the more second nature to you they will become. Your master version of your photos contains the bricks and mortar of your personal photo collection. After you have these organized, accessible, and safely stored and backed up, the possibilities are endless for what you can do with them.

Next, in Part II, I will gently guide you through the eternal enjoyment process of your photos. Sound like a strange cult procedure? It ain't! Simply get ready to share your photos with friends, family, and the world!

Oh, yeah—I don't want to jinx it, but my laptop appears to be working again after sitting in the sun for 4 hours.

Beyond the Box: Backup Resources

Set a plan for backup, do it once, and you'll hardly have to stress out about it again because you'll now have a repeatable system. Here are some resources to get you started. Believe me, things are changing fast in this field, size-wise and price-wise, so by the time you read this, backup options will be even bigger (in smaller containers), better, and cheaper.

Additional Backup

If you're just getting started on creating an organizational and backup system for your photos, I've successfully convinced you to back up, but you can't run out and buy two hard drives right at the moment, at least try to get your photos backed up onto something, anything, as soon as possible. Some of your options include music players, flash drives, online space, CDs, DVDs, and Blu-ray.

iPods and MP3 Players

If you have an iPod or MP3 music player that has free space, you can drag and drop your photo collection there.

Drag your photos into your iPod.

To find out how much hard drive space your photos need and whether they'll fit on your music player, you'll need to compare the remaining free space on your player to the size of your Photos folder. In Mac OS X, click once to highlight your Photos folder and then press Command+I to open its Info box. Under General, note the size of the folder. In Windows, click the folder, press the Ctrl key, and then choose Show File Properties from the context menu to view the size information.

If you're like me, you won't have enough space on your music player to hold all your photos (because music and videos are on there, of course). I'll leave it up to you whether to go without some traveling songs while you wait to purchase some real backup solutions.

Flash Drives

USB flash drives are a possibility for temporary backup too. These are also called *data sticks* and *thumb drives* (perhaps because they're the size of your thumb and you use your thumb to plug them into the side of your computer), and they hold a lot of data these days. For less than $100, you can purchase a 32GB USB flash drive on Amazon.com. That's a lot of space for a storage device that fits in your pocket or on a keychain and that can be tossed around like a hockey puck during the Stanley Cup Finals (maybe hold off on that much tossing around, but they are very stable, with no moving parts inside). Because of their diminutive size, they're also as easy to lose as a unicorn at a Renaissance faire, so it helps to have a dedicated place for them (like on your keychain) so that they don't go missing.

Just…no, not a good idea.

Online Services

For monthly or yearly fees, there are online services that claim they can keep your photos safe for you. These services will usually back up your photos on multiple servers in multiple locations that you will never visit. However, this raises the question: What if the online storage service goes out of business? My opinion is that these services are very good as an additional form of backup to complement your initial backup copy of your photo collection. When you're considering an online service to use for storage, you should check the following:

- How much space is offered
- Whether space is limited per month

- What limits, if any, there are on the size of files uploaded

- Whether your photos are compressed or downsampled on upload

- Whether there is any disclaimer about what happens to your photos if your account abruptly ends or the service goes out of business

- How much of a pain it is to upload to the site (uploading photos one by one can be tedious)

Your photos, backed up online.

Here are some of the more consumer-geared online storage options especially for photos:

- Flickr (www.flickr.com): With Flickr's pro membership for about $25 per year, you can have unlimited storage space. Photo size limits are 20MB, and tools make batch uploading possible. You can download your original photos, but, unfortunately, the service assigns a new, complicated numerical filename to each photo you download (which totally goes against "Step 5: Never Alter Original Files and Camera Filenames" in Chapter 2, "Making a Home for Your Photos").

- Winkflash (www.winkflash.com): With Winkflash, you get unlimited storage for free and the ability to download your original high-resolution photos with original filenames

intact. But there are no utilities for batch uploading. It does have a CD Mailer Program that allows users to send multiple photos on CDs that they will provide.

- Shutterfly (www.shutterfly.com): Shutterfly offers you unlimited storage space for your photos and, for a fee based on the number of photos ($9.99 for 1–100 photos; $14.99 for 101–500; $19.99 for 501–1,000, at this writing), it will send you an archive DVD of your original photos.

For more than just photos, there are services designed to back up all the files on your computer—including photos, music, documents, and e-mail—to a remote place. So, if a meteorite destroys your house, all of your files will be retrievable via download or can be delivered to you on DVDs. Because of file transfer speeds over the Internet, if you are backing up every single image, song, movie, and document on your computer (say, more than 100GB of data), the first time you back up it could take a very long time—weeks, in fact. The good news is that these online backup services can run in the background while you go about your work.

Mac Only

- Backup 3 (*http://support.apple.com/downloads/Backup_3_1_2*)

Mac and Windows

- Backblaze (*www.backblaze.com*)
- Carbonite (*www.carbonite.com*)
- CrashPlan (*www4.crashplan.com*)
- Mozy (*www.mozy.com*)

Backblaze, Carbonite, and Mozy are all about $60 per year. Backup 3 is free but works only with a MobileMe account, which costs about $100 a year. CrashPlan has a free option to back up to another remote computer of your choosing, for instance a computer at your office or a friend's laptop. Its online option is $0.10 per gigabyte per month, with a minimum of $5 a month.

DVDs, CDs, and Blu-ray Discs

Speaking of DVDs, I've always been very wary of using DVDs and CDs as a means for backing up photos. It's not just because research has determined that they degrade over time. Honestly, I find them annoying.

They take up a lot of physical space in their little jewel cases or in sleeves filed in binders. I also have terrible handwriting, so when I write on them to note what they are, it just looks messy and unprofessional (and putting them through a printer or labeling them is ill-advised for archiving—the inside of a CD/DVD drive gets hot, and printing ink and labels could melt over time, damaging the disc and gumming up your drive). But mostly I just get impatient during the process of taking them out of their case or sleeve, loading them into the computer, waiting for the computer to acknowledge them, and so on. And if you have a lot of photos to back up, DVDs and CDs are relatively tiny at 4GB and 700MB, respectively, so that means fewer photos per disc and more loading and unloading.

Yikes!

However, now there are Blu-ray discs, which can hold close to 25GB of your photos (50GB if you can use dual-layer, or double-sided, Blu-ray discs). That's a lot more photos to fit, less loading and unloading, and smaller physical space taken up by your collection of backup discs. As a method of backup, Blu-ray is less labor intensive than burning photos to six times as many DVDs. It could be a reasonable solution if you don't have a second hard drive or if you want to keep a backup on a different form of storage than a hard drive, for diversity's sake.

Comparing Hard Drives

Careful!—don't make funny faces at your hard drive.

You're probably wondering which is the best hard drive manufacturer. As digital asset management guru Peter Krogh, author of *The DAM Book: Digital Asset Management for Photographers, 2nd Edition*, says about hard drive brands, "Any drive can fail. The best drive is one that's backed up." Hard drives can fail at any moment for seemingly no reason whatsoever. But, on the other hand, they can last a long time too—especially if you're good to them and don't shake them, drop them, stack lots of things on them, block their air holes (ventilation), or look at them funny. It's simply, how shall I say, a crapshoot.

For shopping purposes, however, here are some hard drive Web sites that you can browse:

- Hitachi Global Storage Technologies (*www.hitachigst.com*)
- LaCie (*www.lacie.com*)
- Maxtor (*www.maxtor.com*)
- Seagate Technology (*www.seagate.com*)
- Western Digital (*www.wdc.com*)

If you're a Mac user and you want a little more of a hands-on experience, going one step beyond the backup recipe in this chapter, visit the Web site of a company called MacGurus (*www.macgurus.com*). The company does a fair bit of handholding, too, in providing great customer service. They are a key place to start for purchasing external hard drive enclosures, or just a bunch of disks (JBODs). JBODs hold multiple drives

in one container and are an efficient and economical way to store your data.

To really get the lowdown on digital asset management on a professional level, and to learn loads of information on hardware systems for backup, I recommend getting a copy of *The DAM Book: Digital Asset Management for Photographers, 2nd Edition*.

Redundant Storage

Redundancy, in the world of hard drives, indicates that you have one storage machine where all of your data is spread across more than one drive, but all drives in the machine show up as one unit to your computer. That way, if one of the drives fails in the machine, you still have everything on one or more other drives. Typically, these machines are called *RAID systems*. (RAID stands for *redundant array of inexpensive disks* or sometimes *redundant array of independent disks*.)

It's important to remember that RAID is a good solid backup copy of a collection, but you shouldn't rely on redundancy to be a master collection and its backup in one package. A RAID system is continually backing itself up by spreading all data across the hard drives it encompasses, but it isn't immune to power surges or fundamental system malfunctions. You should still have another copy as a backup for your photo collection.

Because RAID systems do sometimes require some technical knowledge to set up and maintain, a company called Data Robotics has developed the Drobo (*www.drobo.com*), which is RAID-like in its redundancy but pointedly consumer-friendly. You plug in a Drobo as an external drive, and you're ready to go. Also, the Drobo lets you upgrade any of its four drives to bigger drives as you run out of space (and while the machine is still running). Drobo will incorporate the new drive's additional space into the system overall. In comparison, with a typical RAID system, the overall size is determined by the size of the smallest drive, so if you want to make the thing bigger, you need to shut down the whole system and replace all drives.

RAID systems and Drobos are relatively expensive when all is said and done. At the time of this writing, the second-generation Drobo starts at about $430 for an empty enclosure (in which you would be installing two to four Serial Advanced Technology Attachment [SATA] hard drives at an additional cost). However, the first-generation Drobo, which connects with USB 2.0 (as opposed to the second generation's additional, slightly speedier FireWire 800 option), was selling for $350 for a while after dropping from an original price of about $500, proving that the cost of storage only goes down.

Starting at about $330 for 1 terabyte, LaCie's 2big Triple hard drive has consumer-geared RAID capabilities and storage. That 1 terabyte, when you add RAID to the mix, is effectively half that size (because the data is spanned across two disks). Do a Google shopping search for RAID hard drives, and you'll find systems that go well into the thousands of dollars.

Redundant storage is a very clever way to make an imperfect machine (the spinning hard drive) that much more secure. I was always impressed by my friends who, when they found a great pair of shoes that they loved, would buy more than one pair at a time, anticipating that the first pair would eventually wear out and they could rely on the next pair to step in (literally). RAID and Drobo technology is like this—you know if one drive fails, there's another in the machine that will pick up the slack. If you're the sort who likes to buy more than one pair of the same shoes, redundancy may be the way to go. (And with Drobo, with its ease of upgrading, you have the option to put new soles or different-colored shoelaces on those shoes as you wear them.) But redundant storage is indeed a slightly (and sometimes more than slightly) expensive alternative to the straight hard drive setup.

Take a Ride on Time Machine

Time Machine, a physics-bending new feature in Mac OS X Leopard, can back up everything on your computer and send you back in time. OK, maybe it's not really physics-bending, but Time Machine does let you retrieve files that you may have

accidentally deleted—enabling you to revisit your computer's filing system as it looked days or weeks ago.

Time Machine automatically and incrementally backs up your files every hour and keeps versions of those files if they change or get deleted. Then, when you tell Time Machine you want to retrieve a file you know you had for sure last Wednesday at 3 p.m. (but now seems to have been deleted into the ether), Time Machine will show you what your computer looked like at that time and let you restore that file to your current computer filing system. Time Machine could be very handy for backing up your photo collection if you're using Mac OS X Leopard and you keep the master version of your photos on your computer (because your internal drive is 320GB or more, as mentioned earlier in "The Master Version of Your Photos").

Here are four tips to remember with Time Machine:

- You can back up only what's on your computer, not what's on an external drive connected to your computer.

- It's best to have one dedicated external hard drive—with nothing else on it to eat up space—that's bigger than your internal drive. That's because Time Machine keeps those multiple versions of your backup—to go back in time.

- You have to turn on Time Machine (choose Apple > System Preferences > Time Machine, and drag the slider to On).

- Time Machine works only if the dedicated drive is connected to your computer—unless you're using Apple's Time Capsule as well, which is a Wi-Fi base station and external hard drive that receives your data wirelessly by using Wi-Fi technology.

Determining the size of the dedicated drive where Time Machine will store the backup files depends on how much you delete and alter files. If you're following the directions in this book, you'll always be adding to your photo collection and not deleting or altering photo files. So, as far as your photos are concerned (your master collection and duplicates for sharing and reference), the Time Machine backup will generally match the size of your master collection on your computer.

However, you'll want to back up other files as well. Time Machine automatically backs up each incarnation of Microsoft Word documents, edited movies, and calendars that you may continually open, alter, and save. For instance, if you keep an ongoing journal in one Word document, Time Machine will back up multiple versions of that journal as it changes on a daily basis. So, as is usually the case with storage, bigger will be better when you use Time Machine.

Backup Software

It's quite possible that the new external hard drive that you bought comes equipped with backup software, a solution well worth taking advantage of. The following are some other options as well. These backup applications are generally cheap (about $30 or free) and have the ability to target specific folders on your computer to back up.

Mac Only

- ChronoSync (*www.econtechnologies.com*)
- Déjà Vu (*www.propagandaprod.com*)
- SuperDuper! (*http://shirt-pocket.com/SuperDuper*)
- Time Machine (*www.apple.com*)

Mac and Windows

- Memeo AutoBackup Standard (*www.memeo.com*)
- EMC Retrospect (*www.retrospect.com*)

Windows Only

- Genie Backup Manager Home (*www.genie-soft.com*)
- SyncToy (*www.microsoft.com/prophoto/downloads/synctoybeta.aspx*)
- NTI Backup Now (*www.ntius.com*)
- Roxio BackOnTrack (*www.roxio.com*)
- Second Copy (*www.secondcopy.com*)

part 2

Your Photos
to Share

and Photos Shared with You

five

Downloading Photos to Your Computer

Good Old Drag and Drop

The most basic way to get photos from your camera to your computer doesn't use an application and is completely guided by you. This chapter teaches you how to disable applications that automatically import your photos for you and put those photo files into elaborate and obtuse filing systems. Such systems make photo files hard to find, and they're hard to undo—thus making you addicted to their wares. Let *The Digital Shoebox* be your Betty Ford Center. We'll get through this together!

After you've learned to avoid the auto-opening of imaging applications, this chapter will also show you the ins and outs of easily dragging and dropping your photos into your year and month filing structure on your own.

Why You Should Know How to Download on Your Own

My grandmother, or Gummy, as I knew her, was a very special lady. Besides having the elegance, grace, and composure of a queen, she also had a unique quality that you might not expect from a nonagenarian: She loved technological gadgets. When she bought gifts for her children, these gifts were not ties or winter gloves. No, sir, she would buy them the latest wireless atomic clock or a weather-predicting tool or a GPS locator for their car keys. She definitely passed this tech predilection on to my father and, subsequently, to me.

Technological gifts are great.

I deeply appreciate technology that accomplishes that which I cannot. Still, I don't like technology that claims to make life easier when, in fact, it's making life more complicated. iPhoto, for instance, gets in between you and your photos by defaulting to a proprietary method of filing your photos by each individual day so that locating them is unintuitive (as mentioned in "But, Wait, Where Are My Photos?" in Chapter 2, "Making a Home for Your Photos"). Just as a machine that eats your food for you is a bad idea, an application that files your photos for you and makes it hard to find or access those files is a technology that you don't need. When it comes to your photos, you're the one who should know how to steer the ship. Manually downloading your photos will give you a better sense of what those photo files are all about.

Do you think surgeons just flick the on switch to activate those robots that go in and perform microsurgery on you? No, of course surgeons have studied for years and years the inner workings of your body according to their specialty. They use technology that assists them and that gives them control. (And I'd even speculate that if they had hands small enough, they would want to be the ones doing that surgery on you, putting those robots out of business!)

You wouldn't want it this way, right?

You're in control when you do the downloading.

My point here is, when you're downloading your latest photos, you need to see the icons representing your photo files and all their numbering and little .jpg extensions; you need to be keenly aware of where these photo files are in your computer and how they got there.

Disabling the Auto-Open Function in Photo Applications

Pretty much everyone I know has a computer that comes with software that opens automatically when it even smells the scent of a camera's memory card on approach. (Yes, I'm talking about iPhoto here—but there are others too, like the photo-management software that came on a CD with your camera if you installed it.)

Let me guess, there's a camera nearby.

I'll tell you how to stop these offending applications from auto-opening when you plug in your camera or memory card reader. And if you've just cracked the box on your new camera and you're holding the CD with its accompanying software while reading this book, you may be asking yourself, "Is she saying that I shouldn't install whatever is on this CD in my computer?" I am saying, "Affirmative! Put the CD back in the box and forget about it!" You don't need it. Now let's get back to the software that may already be on your computer.

What follows are instructions on how to disable auto-opening in iPhoto on the Macintosh and how to disable auto-opening in Windows.

As a knight must travel over hill and dale to vanquish the wretched dragon in its own cave, you must actually go to the source and run an offending application to behead the auto-open function.

How to Disable Auto-Opening in iPhoto on the Mac

Depending on which version of iPhoto you're using, you'll have to look in one of two places to disable this function.

In iPhoto '08 and later, you can disable auto-opening in iPhoto by following these steps:

1. Open iPhoto from your Applications folder or your Dock.

2. In the menu bar, choose iPhoto > Preferences.

3. In the General section, from the "Connecting camera opens" list, choose "No application" (**Figure 5.1**).

And you're set. Dragon beheaded.

FIGURE 5.1 Select "No application."

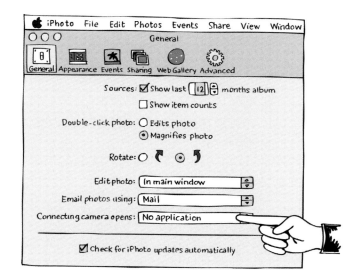

iPhoto 6 controls its auto-opening through its sister application, also Apple-made, called Image Capture:

1. Go to your Applications folder on your computer, and double-click Image Capture to open it.

2. In the menu bar, choose Image Capture > Preferences.

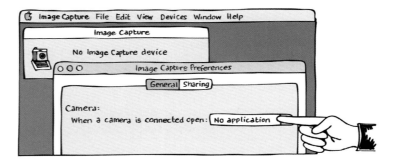

(REMINDER)

Disabling Auto-Opening from the Get-Go

You have a chance to disable auto-opening the first time you connect your camera to the Macintosh or the first time you open iPhoto. When you do, your screen will display a message asking whether you want iPhoto to open each time you connect your camera to your computer. Answer no, and you're all set.

3. In the General section, from the "When a camera is connected, open" list, select "No application" (**Figure 5.2**).

4. Quit Image Capture.

FIGURE 5.2 Select "No application."

How to Disable Auto-Opening of Photo Applications in Windows

Follow these steps to prevent the auto-opening of photo applications in Windows:

1. In Windows, connect your camera or memory card reader to your computer.

A dialog opens, saying that Windows can perform the same action each time you insert a disc or connect a device with this kind of file. You can choose from various options, most of which will be to browse pictures or acquire pictures with various applications.

2. Select "Open folder to view files using Windows Explorer" (**Figure 5.3**). This option displays photo files in a new window of My Computer.

3. Select the "Always do the selected action" check box.

FIGURE 5.3 Select "Open folder to view files using Windows Explorer."

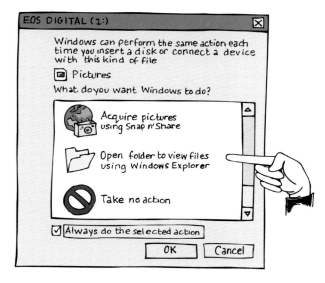

How to Manually Download Photos to Your Mac or PC

Here's how to download your photos and see which files you're transferring in the process:

1. Plug into your computer either your camera, using the cord that came with it, or your card reader. (For more on card readers, see this chapter's "Beyond the Box: Card Readers, Memory Cards, and Wireless Photo Transfer" section.)

2. In the sidebar of your Finder or My Computer window, or on your desktop, find the drive icon that represents your camera (**Figure 5.4**).

$\boxed{\text{FOOD FOR THOUGHT}}$

When You Simply Can't Disable

I have a first-generation iPhone that doesn't show up as a drive icon in my Mac Finder when I connect the iPhone to my computer. If this is the case for you too, there is a way to send photos where you want them from iPhone. On the Macintosh, you can use Image Capture to direct only the photos you want to your year and month filing system.

1. On the Macintosh, start by connecting your iPhone to your computer, either by using the iPhone dock that came with your phone and plugging that into your computer's USB port or by just plugging that USB cable directly from your phone to your computer.

2. With your iPhone connected to your computer, open Image Capture.

3. Select your correct month folder from the Download To option in the drop-down list.

To download only new photos with Image Capture, click Download Some, and select only the photo files that you want.

For Windows, you might consider downloading a free application called DiskAid (*www.digidna.net/diskaid/*).

1. In Windows, run DiskAid while you have your iPhone connected, and select Media Folder from the drop-down menu at the bottom of the dialog. A DCIM folder will show up in the left of three columns.

2. Select the DCIM folder to have the middle column show you subfolders containing your photos.

3. Select one of those folders, and the right column will show your photo files.

4. Either click the Copy To Folder option on the top and target your year and month folder to download all of the photos or select individual photo files to download.

Unfortunately, DiskAid only lets you download all files or one file at a time. So, if you really want just the new photos and you want to streamline this process, download them all to a new temporary folder on your desktop, and move only the new files to your year and month folder.

FIGURE 5.4 These are your photo files; select and drag them to the correct month and year folders.

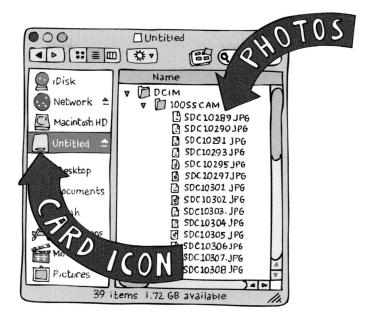

3. Double-click this icon to open its contents. You'll see a Digital Camera Image (DCIM) folder within.

 DCIM is a standard way that camera manufacturers indicate the root folder that contains photo files from digital cameras.

4. Double-click the DCIM folder to open it, and display one or more folders inside.

5. Double-click any of those folders, and you'll see your photo files. You'll return to this folder in step 8.

6. Open another Finder window by choosing File > New Finder Window (Mac), or choose Start > My Computer (Windows).

7. Navigate to your correct month folder in your year and month filing structure.

8. Return to the DCIM folder that you opened in step 5 to display your photo files, and select all of them either by dragging a selection marquee over all of the filenames or by simply pressing Command+A (Mac) or Ctrl+A (Windows).

9. Click any of the photo file icons and, while holding down the mouse button, drag this mass of files into your month folder. Then drop them by releasing your mouse button.

$\boxed{\text{REMINDER}}$

More Than One Folder in Your DCIM?

When you shoot lots of photos without downloading and formatting your memory card, your camera will separate these photos into folders of a set number of photo files (usually 100 or 1,000) and file these in separate folders in your DCIM folder. One folder set might contain IMG_0200.jpg to IMG_0299.jpg, and another folder might have IMG_0300.jpg to IMG_0399.jpg. Be sure to download photos from all of these individual folders in the DCIM folder to the correct month folder.

No Double Downloading, Dig?

If by chance you download a bunch of photos to your month folder and then take more photos without formatting your memory card, don't worry—it's OK! As you're dragging and dropping your photo files, your computer will always warn you if you've previously downloaded any of those files into your year and month filing structure. Applications that import or acquire your photos for you will also generally warn you or ask whether you're importing photos that you already have.

But, sometimes, applications that import your photos for you are intelligent enough to add photos to a collection without overwriting the original imported copies. These applications add something on the end of the file, like an underscore and a 1, just in case that file with the same name is actually a new photo (**Figure 5.5**). This would be helpful if your file numbers were resetting after you formatted your memory card each time and therefore two files with the filename DSCN_0001.jpg were indeed two different photos. But, because you're following "Step 2: Don't Let Your Camera Reset File Numbers," this probably won't be the case. Having two copies of every photo in a folder, one of which has an underscore and a 1 attached to the filename, is simply eating up unnecessary space on your hard drive.

FIGURE 5.5 Double-downloaded files that didn't overwrite original files might look like this.

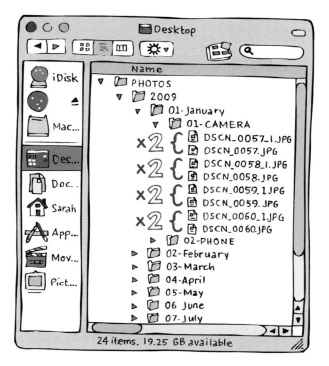

Knowing how to download only new photos will avoid any question as to whether old photos should be overwritten in the first place. When you're ready to download the next batch of photos, just look in your month folder on your computer or your dedicated external hard drive and see what photo file number you're up to. Then find that photo file number in the DCIM folder within your camera drive icon, and select and drag over all the photo files with higher numbers to your month folder (**Figure 5.6**). Then go back and format your memory card (see the next section).

FIGURE 5.6 Select only new files, and drag to your month folder.

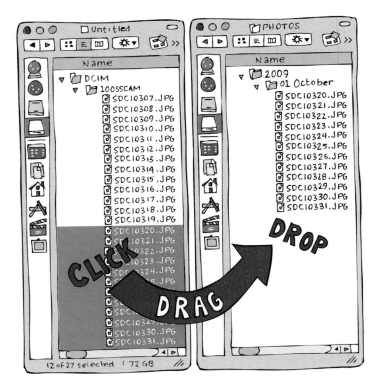

Now, Format That Memory Card

After you've downloaded your photos, you need to format your memory card by deleting all the photos in your camera. To format your memory card, follow these steps:

1. Eject from your computer the device you used to download your photos:

 • If you were using a card reader drive for the downloading, eject that drive from your computer, take the card out of the drive, and replace the card in your camera.

 • If you connected your camera straight into your computer, turn the camera off, eject it, and disconnect it.

2. Make sure that you've backed up your photos at least once since you transferred them to your computer. See "How to Back Up Your Photos" in Chapter 4, "Preserving Your Photos Forever."

3. In the menu of your camera, use the arrow buttons to navigate to Format.

The Format option usually appears in the menu when your camera is in playback mode (the mode you use to view your photos). The option could also be in the wrench or toolbox menu.

4. Select Format, usually by pressing Set or the Menu button again.

5. When your camera asks whether you really want to format your memory card (which is nice of it to do, because this will delete all your photos), select Yes (**Figure 5.7**).

Your camera will wipe the memory card of all photos and prepare it for taking more photos.

FIGURE 5.7 Select Format and Yes to wipe your memory card of all photos.

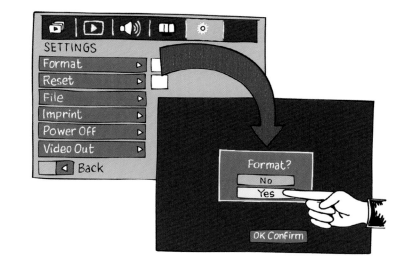

Warning: Avoid In-Camera Deleting

Try not to delete too many photos while you're shooting. You can always get rid of them later after they're downloaded. Ultimately, deleting single photos in-camera is not great for your memory card. The card's internal filing could get jumbled, and this may cause image storage problems before you get a chance to format the card. If you want to delete files for good, do it after you've downloaded your photos to your computer.

Beyond the Box: Card Readers, Memory Cards, and Wireless Photo Transfer

The Card Reader

If you really like plugging your entire camera into your computer with a USB cable to download your photos, keep on keepin' on, as they say. But the other way to do it is to find where your memory card is in your camera (**Figure 5.8**), remove it, plug that into a card reader (or as my dad calls it, a tiny disk drive), and then plug that into your computer (**Figure 5.9**).

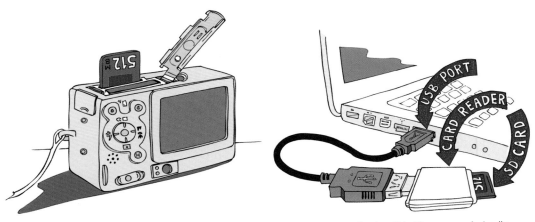

FIGURE 5.8 Memory cards are usually slotted in behind a small door on your camera.

FIGURE 5.9 How the tiny disk drive, as my dad calls it, gets plugged into the USB port on a computer.

Sound like an extra unnecessary step? Maybe. But some cameras don't show up as a drive icon when you connect them directly to your computer. In that case, the only way to drag and drop is to connect the card via a card reader. Also, when you download by using a card reader, you aren't running down your camera battery (which can be expensive to replace) any more than you need to. And, if your battery does happen to conk out mid-download, this can lead to bad things happening to your files (possible file corruption). The moral of the story: Use a card reader.

Another benefit of the card reader is that, if you have more than one memory card, you can be downloading one to your computer while you head out and shoot some more with the other—your camera isn't tied up while you're downloading.

Quality Cards

Memory cards aren't something to skimp on. More-expensive brands are more likely better. I'm speaking from experience here: Paul (whom you might remember from "Murphy's Law in Action" in Chapter 4) was sold a bargain compact flash memory card once for his DSLR camera, and it failed miserably like a fair-weather friend in hard times. "Sure, I'll take your photos," it said. Then, "Oh, you want to see those? Nah, I don't feel like it." When Paul plugged in his card reader, his computer wouldn't recognize it as a drive icon in his Finder. I attribute this failure to the low, low price that he was persuaded to jump on by the camera supply salesman. With memory cards—and any storage, for that matter—don't cut corners. The most widely used and trusted brands of memory cards are SanDisk, Lexar, and Delkin Devices, but brands like Kodak and Panasonic also produce cards that I consider trustworthy.

Memory card readers, however, always seem to be pretty darned cheap (between $10 and $30). I've had a problem with only one, because it couldn't read a card that was bigger than 2GB (and mine was 4GB). SanDisk, Lexar, and Delkin Devices also make memory card readers (**Figure 5.10**). Just make sure you get one that reads your kind of card.

Point-and-shoot cameras typically use Secure Digital (SD) cards, which are smaller than the CompactFlash (CF) cards used by DSLR cameras. Your cell phone may use an SD card but more likely takes a microSD card, which is even smaller than an SD card.

FIGURE 5.10 The Lexar 12-in-1 Multi-Card Reader.

Wireless Transfer

There's another way to get photos from your camera to your computer. Eye-Fi and Lexar (using Eye-Fi technology) make memory cards that wirelessly transfer your photos over your Wi-Fi network at home or in certain Wi-Fi hotspots.

Once registered with the Eye-Fi service, as long as your camera is on and you are within range of a registered Wi-Fi network, your photos are transferred to a place that you designate on your computer or external hard drive. And when I say a place that you designate, I'm talking about those month and year folders you learned about in "Step 4: File Your Photos by Year and Month" in Chapter 2! Additionally, Eye-Fi can be set to send your photos to a selection of online services, such as Flickr, Facebook, and Picasa for sharing or storage.

There are a few versions of the Eye-Fi card. The most basic and inexpensive (Eye-Fi Home 2GB, about $50) allows for wireless transfer of JPEGs over your home network. The card with the most features (Eye-Fi Pro 4GB, about $150) includes geotagging, Wi-Fi transfer through a network of hotspot access points (other than your Wi-Fi at home), wireless photo sharing to online services, video file transfer, and raw file transfer (for information on raw files, see Appendix B).

The geotagging feature of the Eye-Fi Explore Video 4GB (about $100) and Pro 4GB is a fun feature, sure to come in handy years from now if you've forgotten where you were when you took your photos. As long as you take your photos using these memory cards somewhere there is Wi-Fi in the air, the Eye-Fi service will determine your location and plug the coordinates into the metadata of your photos (see Appendix C for more information on metadata).

Wireless photo transfer makes downloading your photos as easy as turning on your camera. Camera manufacturers have been flirting with built-in Wi-Fi transfer of photos for years, but consumer-geared models with this feature have not yet flourished. Eye-Fi's and Lexar's memory cards bring the Wi-Fi transfer technology to all SD memory card-compatible cameras. ■

six

Photos for Printing, Sharing, and Reference

Your Photos: They Live!

If a tree falls in the woods and no one is around to hear it, does it make a sound? Maybe it does, maybe it doesn't. But how about this one: If a digital photo is taken and downloaded to your computer and no one ever sees it, does it make a picture? No! What you have here is a JPEG file on your hard drive and nothing to show for it.

Share your photos with the world!

Viewing your photos is the whole point of taking them, right? This chapter explains how to search for and duplicate your best shots for printing, sharing online, and filing for reference without compromising the integrity of your original master collection. Take a look!

Remember Not to Mess with Originals

Let's take a moment to review "Step 5: Never Alter Original Files and Camera Filenames," covered in Chapter 2, "Making a Home for Your Photos." To keep your master photo collection pristine and untouched, you'll make duplicates of any photos

that you want to have fun with. You'll file these duplicates separately from your year and month filing structure according to their use, in folders called Print, Share, and Reference (**Figure 6.1**).

FIGURE 6.1 Meet the subfolders!

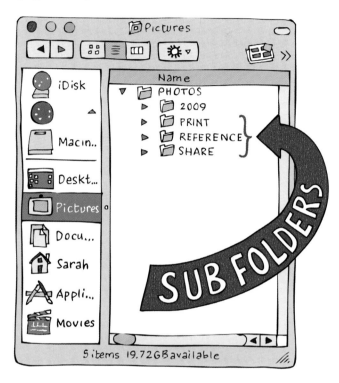

Create these folders (Print, Share, and Reference) in your Photos folder along with your year folder. When you know you want to select some photos to print, share, or file as reference, create a new folder in the corresponding subfolder with a name that includes the day's date (with a year, month, day format) and a descriptive indication of what the photos are selected for.

For instance, say you decide on November 23, 2010, to print some photos of your daughter Jessica starring as Buttercup in her high school production of Gilbert and Sullivan's *HMS Pinafore*. You would make a folder called 101123-Jessica-Buttercup in your Print folder. Or, if on the same day you want to share some photos of your husband raking leaves over the

weekend by posting them to Facebook, you would create a folder called 101123-Facebook-Jim-Leaves in your Share folder. This way, you have a record of all the ways in which you've enjoyed your photos, because they're filed chronologically and according to their use.

If I can't remember whether I sent a certain photo to my mom already, I open my Print folder and look for folders dated after the photo was taken that are also called to-Mom. I double-check the photos that are in these to-Mom folders to see whether the photo in question is included. If it is, I know I don't have to send it to her again.

Here's one from when Mom visited in 2005.

Selecting and Duplicating Your Best Shots

The first step in sharing your best shots is to determine which photo files you want to share by viewing them in an image browser. Then, you'll be using keyboard shortcuts to copy and paste them. Here's how to select and copy your photos:

1. Browse your photos in Preview or Quick Look on the Macintosh or in Windows Photo Gallery.

2. Write a list of the filenames that you want to share.

Tip: You Can Skip Writing Down Filenames

You can also print a list of the photo files that you're browsing by selecting them all in the Finder (Mac) or My Computer (Windows) view and then choosing File > Print. Then, while you're browsing, you can check off the filenames that you want to select for printing, sharing, or reference.

3. After you have your written list, go back to your Finder or My Computer view, and select each file on your written list by clicking the file once while holding down the Command key (Mac) or the Ctrl key (Windows) (**Figure 6.2**).

FIGURE 6.2 Command-click or Ctrl-click to select and then copy and paste.

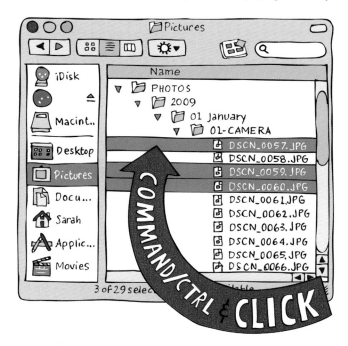

4. After you've selected the files on your list, press Command+C (Mac) or Ctrl+C (Windows) to copy those files.

5. Open a new Finder or My Computer window, and navigate to the dedicated folder for these duplicates in your Print, Share, or Reference folder (for instance, 091203-E-mail-Jake-Birthday).

6. Open this dedicated folder and press Command+V (Mac) or Ctrl+V (Windows) to paste all of your photos to be printed, shared, or filed as reference into this folder.

(FOOD FOR THOUGHT)

How to Leave a Trail for Yourself on a Mac

Instead of writing down filenames when you select your photo files, on the Macintosh you can color-label them. This makes selecting them a matter of sorting them by label in your Finder window and selecting them as a group.

To label your files, select a file by clicking it once, choose File, and under Label click a colored dot. To sort by color label, select the hard drive or folder with your labeled files. To display a Label column to the right of the other columns in the hard drive or folder window, with a Finder window open, choose View > Show View Options, and select the box for Label. Then click this column to line up the color-labeled files underneath each other.

They'll be easy to select by clicking the first file, holding down the Shift key, and then clicking the last in the selection, or you can click once and drag your selection marquee around all of them.

You can also customize these labels by choosing Finder > Preferences > Labels and assigning text to each of the colors. For instance, if you know you want to print photos for a set number of pages in a photo album, you could rename red to Definitely Print and orange to Maybe Print. Make an initial pass of selecting by using these Definitely Print and Maybe Print labels (effectively your first and second choices). Then, if you find you didn't select enough photos labeled Definitely Print, you can choose from your Maybe Prints to fit your target number of photo album pages to fill.

Printing Your Photos

By printing the photos you like from your master photo collection, you're creating a slim and edited version that represents the best of your personal photo diary. Prints are great because they're very much at your fingertips. Photo books, photo albums, scrapbooks, and even shoeboxes full of real, printed photos will always be one of the most accessible places to keep your photo memories for generations to come.

Printing is good for your collection.

Printing your photos by using online printing or print-on-demand photo book services is usually the best way to go. You'll be saving time and money and, most likely, getting very good-looking images. Sometimes, results from an online printing service can be nearly as immediate as printing at home. You can upload your photo files to the photo-printing Web sites of major retail stores like Wal-Mart and Target, and you can pick up the prints at the local franchise an hour later if you don't want to wait a few days to receive your order in the mail.

Making Prints Last

Digital photo prints can last for hundreds of years when stored in optimal conditions. This means keeping them away from the elements in a photo album or framed under glass. How long a print looks its best is known as *print permanence*. Discoloration of the image, as well as fading and degradation of the paper, are all signs that a print's permanence has come to the end of its line. According to Wilhelm Imaging Research, a company in Grinnell, Iowa, that tests permanence in digital

printing, the printing that is typical of most online, retail, and digital mini-labs produces print permanence of more than 100 years in a well-cared-for photo album. Put that same print out on your porch in the sun in a major metropolitan city, and it might look good for only 26 years (city pollutants, such as ozone, contribute massively to the discoloration and deterioration of prints).

Great as it is to hang your photos on the fridge, it's not the best place for print permanence.

You get 40 years of permanence by keeping the print under glass, and you can get another 10 years if the glass is UV-protected. Wilhelm Imaging Research also points out that Hewlett-Packard, Epson, and Lexmark have developed home inkjet-printing systems that last twice as long as standard retail printing.

If you enjoy printing at home, this is good news. Ideally, as a savvy photo-enthusiast and for the sake of your photo albums, you should make print permanence a priority. But, as you might imagine, the time it takes to print at home may dissuade you from making that effort at all. If this is the case, online or professional printing offers a timesaving solution to having prints made.

Everything You Wanted to Know About Print Permanence—and Then Some

If thoughts of print permanence never crossed your mind before, consider the photos in your parents' photo albums that have faded to an unsightly orange or yellowish hue or are bubbling from their paper backing. There are equivalents to this in the digital realm—I certainly have some inkjet prints from a few years ago that have morphed into some pretty funky colors.

Printer manufacturers are coming up with better archival inks and methods of printing every day. Thanks to Wilhelm Imaging Research (WIR), an incredible amount of information on print permanence has been made available so that the general public can check the score on what printing systems kick rear over others. (If you're not so competitively minded, it's just nice to see so much imaging information in one place from such a great company.)

WIR started its work on a 10-year study of color print fading in the '80s. Since then, the research firm has become the foremost resource on finding ways to increase the longevity of your photos and the photos of some very esteemed collections. It has consulted for prominent museums, galleries, and collections. It also studies motion-picture film stock and has served as a technical advisor to film director Martin Scorsese when he successfully campaigned Eastman Kodak and Fujifilm to boost the permanence of their color motion-picture and still film stock. Some films of yesteryear require extensive restoration to be suitable for screening or DVD manufacturing because of color fading and instability of the film stock. WIR and Scorsese helped ensure that future films would be less likely to fade into that pale blue mush of impermanence.

WIR performs brand-specific research on digital printing and posts the results as articles on its Web site (with statistics like those mentioned in the "Making Prints Last" section, which come from "A Survey of Print Permanence in the 4 × 6-Inch Consumer Digital Print Market in 2004–2007" by Henry Wilhelm). In addition to data on digital printing, the WIR Web site has a treasure trove of articles on photography preservation spanning digital, film, and motion-picture formats. WIR also posts non-WIR-published articles from multiple sources about all aspects of photo preservation. (Visit *www.wilhelm-research.com* for more information.)

(FOOD FOR THOUGHT)

Getting the Color That Nature Intended

You can perfect your color printing with printer-to-screen calibration, but this extra step, combined with the expense of buying all that ink and specialized photo paper, increases the appeal of professional or online printing.

It is possible that you'll get great colors from your printer right out of the box, and you should definitely celebrate that. However, if you're unhappy with what you're seeing when you print and you feel ambitious, investigate monitor and printing calibration. It's a big can of worms to get into, but it's still good to know about. Pantone makes something called the *huey*, which will help you with monitor calibration (*www.pantone.com*, under Products > Monitor & Printer Profiling). Spyder calibration devices from Datacolor handle multiple color needs: monitors, printers, and scanners (*http://spyder.datacolor.com*).

You will always find that the image you see on your screen will differ in color and value from what comes out of your home printer. This is because of the nature of viewing an image generated by the light of your computer screen versus the ink process on paper.

A Recipe for Your Printing

Here are some ingredients for a solid photo-printing plan:

- Use an online printing service to do the bulk of your photo album, gift, and general printing.

- For your 4 × 6 prints, invest in a compact photo printer ($100 to $250) that is designed for making such prints at home (for example, a Canon Selphy, HP Photosmart Inkjet Compact Photo Printer, or Epson PictureMate).

 Keep in mind that supplies of ink, paper, or printing kits will cost money over time. Generally, it works out that the cost of a 4 × 6 print from a compact photo printer will range from $0.25 to $0.55 per print.

- When you want something special, like a large print for your wall that is 8 × 10 inches or larger, get it printed online, or develop a relationship with your neighborhood professional lab.

To develop a relationship with a professional photo lab, ask your friends whether they have had any good lab experiences. Or simply try a neighborhood lab and judge their services for yourself. (For online printing resources and details on home printing, see "Beyond the Box: Online and Home Printing" at the end of this chapter.)

Standard letter-sized or multiuse color inkjet printers can be good too, but I find that the multiuse factor tends to mean that one feature may work well at the expense of others. Also, there is an understandable tendency to buy more-inexpensive models, which makes for compromised prints when it comes to color and clarity. Not to mention, these compromised prints can cost you when you don't get the print right on the first or second try, meaning that you end up spending any original cost savings in ink and paper.

Isn't it great getting photos in the mail?

Sharing Your Photos

For photos that you want to share with friends, family, or perhaps your car insurance adjusters, you'll follow the selecting and duplicating method just described for printing, but you'll file the photos in your Share folder (**Figure 6.3**).

FIGURE 6.3 Keep a record of your sharing generosity.

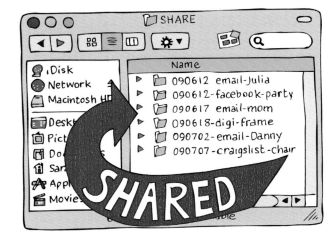

Among other uses, you'll send these shared photos by e-mail; upload them to Facebook, Flickr, personal Web sites, and blogs; put them into digital photo frames; make them into slide shows; burn them onto CDs for friends; or submit them to online photo contests. Basically, if you're sharing an image virtually through your computer, file it in your Share folder. Depending on the photo's destination, you'll resize it—to meet any requirements at the destination or just out of courtesy.

Keeping Shared Photos at Nice Specs

When I go on a trip, I try to keep my packing to a minimum. I think, "Am I really going to need that fifth T-shirt or second pair of sneakers?" I consider the size of my luggage as a courtesy to myself so that I don't have to lug multiple bags to and from the airport. When you're sending photo files over the Internet, you should consider their size as a courtesy to the receiver. You don't want to send more megabytes than are needed or than can get through the recipient's virtual mailbox.

There are three ways to make a large photo file smaller:

- Crop the image by removing part of the composition.

- Use more JPEG compression during the Save As procedure (which removes picture data while retaining pixel size).

- Resample the image with fewer pixels overall.

Because cropping alters the image content and more JPEG compression reduces the quality of an image, consider resampling your photos with fewer pixels for virtual sharing over the Internet to keep your photo looking its best. And remember, you'll always be making these size adjustments to a *copy* of your original file, keeping the original untouched.

On the Macintosh, Preview (version 4 and newer) lets you change the size of your duplicate file by choosing Tools > Adjust Size. Play around with this by selecting different Fit Into ratios until the resulting size accommodates your requirements (**Figure 6.4**). Also on a Mac, Mail lets you choose to send photos at three sizes: Actual Size, Medium, and Small. After you attach a photo at its original size, a pop-up menu will appear in the bottom-right corner from which you can choose your size. Small and Medium are both very e-mail friendly and will send a photo file that's good for viewing but will most likely be a bit compromised in terms of detail for printing at any size bigger than a few inches in width or height (especially with the Small option).

FIGURE 6.4 Resizing using Preview.

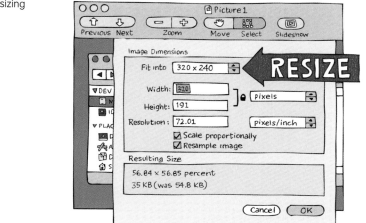

In Windows Photo Gallery, you can also resize an image when you e-mail it. After you've selected an image and clicked Email, you can choose a size for the image you're sending.

As you may know, some online photo-sharing sites require you to keep your uploaded files under a certain size in megabytes. For instance, some social networking sites ask you to keep your profile picture below a certain number of pixels on each side. As technology progresses, this is less of an issue (Web sites may resize your image for you on upload), but it's something you should still understand. For instance, Flickr allows users with free accounts to upload 100 megabytes of photos per month. Facebook doesn't seem to have many limits at all, except that it accepts only JPEG or PNG files.

Fear Not Sending Originals

Downsizing an image is a very kind thing to do when you're e-mailing images to people. Usually, it's best to keep e-mailed images to less than a megabyte. In fact, if you really just want the recipients to see the image but don't expect them to print it, you can make the image as small as the smallest option that still looks good on your own screen. This keeps your friends' and family's in-boxes slim and svelte!

However, if you want to send big original files because you want your recipient to have the best quality possible, this is probably a fine thing to do. The amount of data that most e-mail systems can pass these days is upward of 10 to 20 megabytes, and sometimes more. To give some perspective, JPEGs taken with a 7-megapixel camera range in file size from 2 to 5 megabytes. You can always find the size of a particular file by clicking it once to highlight it and pressing Command+I (Mac) or by Ctrl-clicking the file and choosing Show File Properties (Windows).

Reference Photos

Your Reference folder will be populated with duplicate photos that you've grouped in ways that are logical to you—in other words, for your future reference. Think of it as your personal filing system. Images of you, specific friends, family, pets, places, general interests, and collections are examples of folders that you might create in your Reference folder (**Figure 6.5**).

FIGURE 6.5 A typical Reference folder.

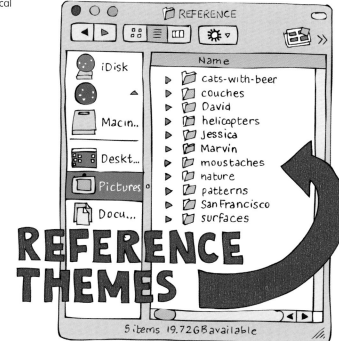

My Reference folder includes a folder called BeckyKyraShiraSarah for all the photos that I have of me with my three best friends whom I've known since high school. I have all of my favorite photos of my sister, Hanna, in a folder called, you guessed it, Hanna. I have a folder of all the photos I like to use as screen savers on my computer, and I have a folder of pictures of a foldout couch that I sold on Craigslist (I could delete that folder now because I did indeed sell the couch, but I like to keep everything, in the name of archives). Basically,

if you take a photo that you think you'll find handy in a collection with a unifying theme, create a folder with the name of that theme, and file it in the Reference folder.

The Reference folder is there to satisfy your need for organizing by theme or event (just make sure that you're always filing duplicates, not your original master copy files, in this filing structure).

Next up, in Chapter 7, "Photos from Friends and Found Images," you'll read that the Reference folder is also a great place for filing photos that are shared with you from friends and family and for photos that you collect from the Internet for reference.

Beyond the Box: Online and Home Printing

When it comes to online or home printing, you may say, "Six of one, half dozen of the other." Or, you may declare, "Are you crazy? Why would I print at home? It's expensive and time consuming." And, of course, you may swear by, "No one can print my photos like I can—I do all my printing at home." Or, maybe you do both, like me, and do a little printing at home and some printing through an online service. Regardless,

what's great is that you and I have choices when it comes to seeing our prints made. What follows are some details on those options.

Online Printing

One interesting thing to think about with retail and online printing is how your prints are processed. Most places use a similar technique to printing from film negatives (remember those?), but instead of creating the image with light projected through a negative enlarger, a laser is used to transfer the digital image to paper. After that, however, the paper is processed through the same chemicals that old-style film prints were.

If you're new to online printing, you may want to pick a service that your friends use or do a little research via Google. Type *online photo printing*, and see what comes up. Most likely you'll see sites like Shutterfly, Snapfish, and Kodak Gallery. But there are many more, such as SmugMug, Fotki, and PhotoWorks. You may want to dig a little deeper on the Help or About sections of these online printing services to see what kind of claims they make on the permanence and quality of their prints. Online photo-sharing sites such as Flickr and Picasa offer printing through their associations with multiple online printing services as well.

Online printing prices vary, but you'll usually find their range to be, by size, as follows:

- 4 × 6 prints, $0.08 to $0.15
- 5 × 7 prints, $0.25 to $0.99
- 8 × 10 prints, $1.49 to $3.99

Some popular online printing services include the following:

- Fotki: *www.fotki.com*
- Kodak Gallery: *www.kodakgallery.com*
- Mpix: *http://mpix.com/*
- Photobucket: *www.photobucket.com*
- PhotoWorks: *www.photoworks.com*

- Shutterfly: *www.shutterfly.com*

- SmugMug: *www.smugmug.com*

- Snapfish: *www.snapfish.com*

- Walmart.com Photo Center: *www.walmart.com/photo*

- Winkflash: *www.winkflash.com*

Many online photo-printing companies offer photo book services as well, and there are several companies that are solely devoted to making custom books, some of which are listed below. Using their free software, you can arrange a layout with photos and captions or other text to make a hardcover or softcover bound book. Consider it a photo album that will never lose a photo.

- AsukaBook: *www.asukabook.com*

- Blurb: *www.blurb.com*

- Fastback Creative Books: *www.fastbackbooks.com*

- Lulu: *www.lulu.com*

- MyPublisher: *www.mypublisher.com*

- PaperChase: *www.paperchase.net*

Home Printing

The three steps of printing.

For home printing, there are many options that will show up in the print dialog of both Preview and Windows Photo Gallery. But you'll want to pay attention to these three basics:

- Select the printer you're using.

- Set the correct page size.

- Scale the photo to fit on the paper the way you want it to look.

On a Mac, for printing using Preview, follow these steps:

1. Open a single or multiple selection of files.

2. Choose File > Print. If only a small pop-up menu appears, click the arrow next to the option that lists the printer you're using.

3. Select your printer, which should appear in the list if you've installed its driver.

4. Set the correct size in the Paper Size option.

5. Scale the image by using a combination of the items under the Preview menu: Center Image, Scale (with your choice of percentage), Scale To Fit, Print Entire Image, or Fill Entire Paper (**Figure 6.6**).

6. Click Print.

FIGURE 6.6 Preview print settings.

If, in Preview (version 4 and newer), you just want to print images for reference, you can use standard, letter-sized paper and print more than one image per page by using the drop-down menu next to "Images per page."

In Windows, using Windows Photo Gallery, follow these steps:

1. Select the photo or photos you want to print.

2. Click Print in the toolbar.

 The Print Pictures dialog appears, where you choose your print options (**Figure 6.7**).

FIGURE 6.7 Windows
Photo Gallery print settings.

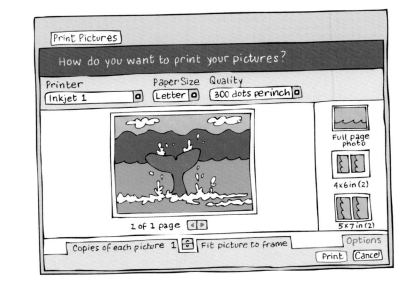

3. Select your printer.

4. Select the paper size, print resolution, and print size (for instance, you could set the photo to print a 4 × 6 image at 300 pixels per inch on an 8.5 × 11 sheet of paper, or you could set it to print more than one image to a page).

5. Select whether you want the printer to scale your image to fill the frame (in which case you would choose your paper and the print would fit to that size).

6. Click Print.

Keep in mind that you need to work with a file that has sufficient resolution to print nicely. (If you followed "Step 3: If You Shoot JPEGs, Set Your Size and Quality to High" in Chapter 1, "Before You Take Photos," this shouldn't be a problem.) Two-megapixel cameras, such as might be found on a cell phone, can take photos that are good for 4 × 6 prints, but any larger than that, print-wise, you're pushing it. The lowest megapixel rating for a camera that you'll want to use for printing 8 × 10 prints is a 7-megapixel camera. ■

seven Photos from Friends and Found Images

Filing the Photos You Didn't Take

If you have followed all the steps so far in *The Digital Shoebox*, you've started to file your photos in your year and month filing structure, and you're feeling very organized. But what about other photos you didn't take that are sent to you from friends and family? Where do they go? They go in a Friends-Family-Photos folder in your Reference folder.

Tip: Keeping Score of Whose Is What
Because your Reference folder is filled with images that you take, as well as found images and those that come from friends and family, distinguish between the three sources by making subfolders in your Reference folder: My-Photos, Friends-Family-Photos, and Random-Photos.

Shared Photos

You probably get at least a few photo e-mail attachments on a regular basis from your friends and crazy aunts and uncles. They might be low-quality JPEGs (because the senders were sensitive enough not to send large files), but they're definitely worth keeping. File these photos in your Reference folder in a subfolder called Friends-Family-Photos (**Figure 7.1**).

FIGURE 7.1 Filing in your Reference folder.

You may say, "Well, my e-mail is fine and organized, and I never delete anything from my in-box. I can always go back and find it in my e-mail instead of filing it in my Reference folder." But wouldn't it be nice to have all the pictures that are sent to you from certain people in one place? If your son Sampson regularly sends you photos of your grandson Sam, start a Sampson-Sam folder. If your friend Jacques always sends you photos from his parties, start a Jacques-Parties folder.

Sending photos from cell phones is so easy these days that you'll likely receive more and more photos from friends and family as time goes on. I know that when my dad embarks on his upcoming cross-country driving trip, he'll be e-mailing me photos from his new phone as he goes. I'll file these photos in a folder called Dad-Cross-Country-Trip.

Traveling with a camera phone makes it easy to share your trip with friends.

Found Photos for Keeps

I don't know about you, but I tend to collect a lot of images as I make my way across the digital expanse of Internet and e-mail. It started because I like to draw, paint, and make comic books, and I use found images for reference and inspiration. Before the Internet, I routinely clipped photos from magazines and deposited them in a set of files that I had labeled alphabetically—ants, buildings, and cheetahs under A–C; horses, igloos, and jets under H–J.

The Internet has brought my image collecting to a whole new level. I now have a folder that I call Random-Images in my Reference folder. That's where I save whatever catches my eye, like Sara Rubinstein's amazing photo of Whiplash the Cowboy Monkey riding a border collie (**Figure 7.2**). You can simply drag and drop an image in your browser (Mac and Windows) or Control-click (Mac) or Ctrl-click (Windows) and save these images in your Random-Images folder. More than a reference library, it's my virtual museum of images that I can visit anytime.

FIGURE 7.2 What more can I say? A wonderful portrait photographer caught the absurd essence of this fantastic moment. Photo by Sara Rubinstein, *www.saraphoto.com.*

My father is a painter, and he collects digital images on a major scale, but not so randomly. He has amassed a library of images that are filed in folders by subject matter. For a painting he did of a turtle turning into a rose, he found his reference images online and filed them in folders called Roses and Turtles. He combined these images to produce something completely new and then used the resulting montage as his model (**Figure 7.3**).

FIGURE 7.3 *Snapper Rose* by Hone Williams.

Perhaps you're moving into a new home, and you're thinking about buying furniture. You could browse around online for photos of bookcases and chairs that you like and file these in a folder called New-House-Furniture. Or maybe you're shopping for a new car—you might need an Awesome-Cars folder. (And then, if you have an image editor like Photoshop, you can paste yourself into the photos to see how good you look!)

Picture yourself driving your dream car.

Copyright, or Using Photos in a Public Way

The nano-primer on copyright.

I'm going to give you a micro-primer on photography copyright law. OK…maybe a nano-primer. (See the next section, "Beyond the Box: A Few Points on Copyright," for the micro-primer.)

In its most basic form, the moment you take a photo, you own the copyright to that photo (unless it's a work-for-hire job, or you took the photo as an employee, in which case the company you work for owns it). Copyright of a creative work—whether that work is photography, writing, music, or otherwise—limits the duplication of that work to be the right of the creator or the copyright holder. Duplication can take the form of using a copy machine in a library, posting on a Web site, or printing in a book, among other uses. Copyright law protects creators, including photographers, from people using their work for profit without their permission (or licensing). Just as it's illegal to steal music and movies from the Internet, especially if you're planning on duplicating them and selling the copies, it's illegal to steal photos if you're planning to benefit from their use.

The funny teeth business—booming.

Still, there are circumstances in which it's OK to show other people's work without paying or permission. For instance, if you were planning to go into the funny plastic novelty teeth business (booming, by the way), you would be breaking copyright law if you used the photo I took of my friend Shira wearing funny plastic teeth to advertise your company without my permission.

However, if you wanted to use the photo of Shira to teach a class about the proper way to wear funny plastic novelty teeth, you wouldn't be breaking the law. Using photos for education, research, criticism, comment, and news reporting is considered *fair use*—as in, it's fair to use the photos for those purposes without permission from the copyright holder.

And if you do have permission to use someone else's photo in a public way, make sure to credit the photographer. All of us like to get credit for our work.

Beyond the Box: A Few Points on Copyright

One of the slippery things about copyright is the way that it's applied on a case-by-case basis. Copyright terms can change depending on when a work was made or whether it was ever printed in a publication. The following information on registering for copyright, length of copyright, and crediting creators will give you a compact overview on the subject of copyright. Some Web resources are included as well.

Registering for Copyright

Despite the fact that copyright goes into effect the moment a photo is taken, professional photographers register their work with the U.S. Copyright Office at the Library of Congress to guarantee that, should someone infringe on their work, they'll be covered for any legal fees that arise from seeking what they're owed in permissions and licensing. In other words, because I haven't registered my picture of Shira in funny teeth with the copyright office (don't get any ideas!), if you do use my photo to advertise your funny teeth business, I can demand that you pay me my licensing fee of one gift basket of champagne and beluga caviar, but I won't win any legal fee retribution when you refuse to give me that gift basket and I have to take you to court (even when I do win my bubbly and fish eggs in the end).

Licensing fees for using copyrighted photos can vary depending on what the copyright holder thinks is appropriate—from nominal fees covering the labor involved in duplicating and delivering the image to thousands upon thousands of dollars (if it's assumed that the use of the image will generate high revenues, such as in the advertising campaign of a popular

product). If copyright holders think that their rights have been infringed upon, they can seek their licensing fee and, if the work is registered, any further retribution needed to cover the legal costs of seeking those fees.

Registering your photos is a matter of sending a fee (which, at the time of this writing, is $35 for online filing and up to $65 by mail) to the U.S. Copyright Office. For that one fee, you can register a collection of photos as long as they are organized in some tidy fashion—for instance, low-resolution thumbnails of the photos on a disc or printed contact sheets of thumbnails— anything that shows enough of each photo to identify the images that are to be registered. The Copyright Office will then send you a certificate of copyright for that collection.

The lowdown on registering for copyright.

How Long a Copyright Lasts

How long a photo is under copyright depends on factors such as these:

- When a photo was taken
- Whether the photographer is still alive
- Whether the copyright has been renewed
- Whether the photograph was ever published in print, such as in a book, magazine, or newspaper

If you took a photo of your dog after January 1, 1978, and that photo has not been published in a book, magazine, periodical, or major Web site, you have a copyright on that photo for the length of your life, plus 70 years.

If you publish a book of photos of your dog and include that photo that you took after January 1, 1978, the copyright (for that individual photo) expires 95 years from the book's publication date or 120 years from the time that you took the photo, whichever comes first.

Why 1978? The U.S. Congress rearranged existing copyright laws in 1976, and these laws went into effect in 1978. What prompted this rearrangement? During the '50s and '60s, photocopiers were becoming the de rigueur office accessory across the nation, and publishers began to fear for the genuineness of their published assets. Congress felt their pain.

Photocopying copyrighted material is a no-no.

If you would like to learn more about copyright, check out these online resources:

- The American Library Association has a digital slider by which you can select your date, and the Web site will tell you about the copyright terms for that date: *www.librarycopyright.net/digitalslider*.

- Lolly Gasaway, professor of law and associate dean for academic affairs at the University of North Carolina, keeps a Web site called "When U.S. Works Pass Into the Public Domain": *www.unc.edu/~unclng/public-d.htm*.

- To go straight to the source, the U.S. Copyright Office explains copyright duration here: *www.copyright.gov/help/faq/faq-duration.html*.

Crediting Photographs

As mentioned earlier in the "Copyright, or Using Photos in a Public Way" section, all photos should be credited to the photographer. However, I just looked in the fridge and saw a box of butter with a photo of a cow on it. It's a very nice cow photo, but I agree that it might be overkill to credit the photographer somewhere on the butter box. The world of advertising and marketing rarely credits its photographers within the space of advertisements and packaging, esteemed as their photographers may be. Photographers should always know on being hired for a job if and in what way they'll be credited for their work based on the contract that they sign with their employer.

Credit for the photographer is a nice thing.

The Web is another matter, however, and it is rife with examples of credit-less photos posted on blogs and elsewhere. It seems a given that copyright rules are trampled like fall leaves. Like so many aspects of our fast, modern world, just because something happens doesn't mean it *should* happen. If you're going to use someone else's photo in a public way, get permission, and credit the photographer; it's the best way to go. ◾

eight
Conclusion

Putting the Lid on the Shoebox

It's about time we started to take photography seriously and treat it as a hobby.

—Elliott Erwitt

I can vividly picture the cardboard box that holds hundreds of photos I took in my teenage years that didn't make it into my diligently kept photo albums. This cardboard box is bigger than a shoebox (and a bread box, for that matter). It's a mess of photos and mismatched, unmarked negatives packed into a storage unit within a hulking complex of buildings overlooking the Schuylkill River in Philadelphia. Before having the box, I remember always feeling slightly irritated that there were so many extra, non-album-worthy prints cluttering up a drawer in my bedroom. And yet I didn't have the heart to throw them out. Someday I'll have to retrieve the cardboard box from that storage unit and relocate it to where I live now in California. Maybe I'll even go through the photos again, pick out a few for some new albums, and regretfully and painfully trash the rest. That won't be easy.

For someone like me, who has a hard time tossing personal photos, the advent of digital photography is a godsend. The cardboard box exists in the form of hard drives. It gives me great peace of mind to know that all my photos are organized and readily available. Of course, the whole point of this is to be able to enjoy my favorite photos, the ones that make it into the diligently kept photo albums, both real and virtually kept online. These are the photos that I'll be returning to again and again over the course of my life.

This is one of my favorite photos: Clo Clo the cat drinking my water.

How Niépce Made the First Photograph

Using a camera obscura containing a treated pewter plate coated with bitumen of Judea that was exposed for 8 hours and then washed with oil of lavender and white petroleum, Niépce produced what he called a *heliograph* of the view from the second-story window of his house in France. He named the process for the Greek words for sun, *helios,* and writing or drawing, *graphein.* He had found that bitumen of Judea, a resinous tar substance that Niépce used in engraving and lithography, bleached to light gray upon exposure to sunlight and hardened to insolubility in reaction to oil of lavender and white petroleum. The exposure time was so long that the image captured sunlight (traversing the sky above) falling on both fronts of the buildings facing the courtyard below. As with the then yet-to-be-invented daguerreotype, Niépce's creation is a one-of-a-kind positive image that is visible because of variations in shininess on the pewter plate.

"Bitumen of Judea? Camera obscura?" you ask. Some vast changes have taken place in photographic technology since then. For example, 0s and 1s of digital information have become the stuff of photos, rather than chemical processes, and exposure times have gone from 8 hours to 1/8000 of a second. (Though if you don't know what a camera obscura is, also known as a *pinhole camera,* I urge you to find out. Worldwide Pinhole Photography Day happens every year in April; see *www.pinholeday.org* for information.)

For decades following Monsieur Niépce's first photo, to make what we now know as photographs took excessive planning and preparation. *Daguerreotypes,* popularized by Louis Jacques Mandé Daguerre (mentioned in "Food for Thought: With Photo Organization, Repetition Is Your Friend" in Chapter 2, "Making a Home for Your Photos"), required a polished silver plate to be coated with silver halide particles, exposed with a camera for up to minutes at a time, and developed using mercury vapor. *Calotypes,* which were invented by William Henry Fox Talbot at around the same time as daguerreotypes, used a prepared base of paper coated with silver nitrate and gallic acid and were exposed in a camera and doused in the same chemicals to produce an image. All of these chemical processes were mixed and applied by the photographer, pretty much at the time the photo was taken. Nowadays, your "planning and preparation" when it comes to taking a photo happily involves how fast you can get your compact point-and-shoot camera out of your pocket.

FIGURE 8.1 *View from the Window at Le Gras,* circa 1826, Joseph Nicéphore Niépce. Harry Ransom Center, the University of Texas at Austin.

Which images make it into your photo albums? What's your life history going to look like 20 and 50 years from now? You wouldn't have been asked this question 200 years ago, aside from painted and drawn interpretations of the world. Exact duplication of what we saw around us was just a speck of a sparkle in the ambitious inventor's eye. By 1826, one of these inventors, Joseph Nicéphore Niépce, created what is considered to be the first permanent photograph still in existence, called *View from the Window at Le Gras* (**Figure 8.1**).

Your photo collection is as much a part of photography's history as it is a part of your personal history because, with every photo you take, you're adding unique information to recorded human history. Who knew your Fourth of July BBQ was so important? It is. The language made of photographs from the last 180 years has provided historians, academics, artists, and family descendants with untold volumes of information—and, yes, enjoyment. Photography has become a living legacy.

With your little history-making machine called a *digital camera,* I hope you take thousands of photos to keep in your digital shoebox. But don't make the mistake of thinking that just because photos are so easy to take and reproduce that they will stick around forever on their own. Now that you have read *The Digital Shoebox,* you know the simple steps that will help you, your family, and your friends enjoy your photos for lifetimes to come. ◼

Happy photo-taking! Photo by Paul Gachot.

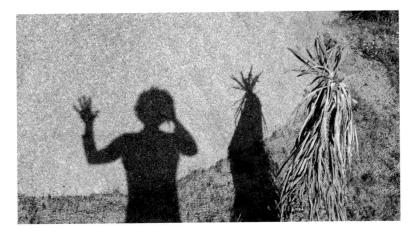

part 3

Some A, B, and Cs for Your Photos

Appendixes and Glossary

appendix A

What Time Is It?

Photography has stopped time for us. With a camera, we capture an instant, and when that capture happens digitally, we have an automatic record of when that instant occurred. Someday, when all digital cameras are capable of wireless Internet connections, you won't have to worry about setting your camera's clock on your own. The current time will be sent to your camera from some bureau of time standards as it is with your Wi-Fi-connected computer or your digital video recorder (like TiVo, which is hooked into a phone line to call mother TiVo each night to confirm the time).

Do you remember seeking out a kind stranger, who obviously had a watch strapped around his wrist, to ask such a question? That's now very old-fashioned. Cell phones and other ubiquitous wired devices tell us the time these days.

Nowadays, you can interrupt someone talking on a phone to find out what time it is.

Telling time has become an ever-present, hands-off element of life. It's likely that the days of hearing people complain about having to set the time on 10 different clocks by hand when daylight saving time rolls around will all but disappear (all the little electric hamsters in those 10 time-telling machines will spring time forward or back for them).

Horologists Love Time

As horologists (those who take joy in studying time) of the world know, the more you think about time, the more there is to think about. You have to admit, it's an interesting topic.

Have you ever stopped to think about how confusing it was in the mid-19th century as trains became faster and rail companies had to coordinate their train schedules between towns with local times that relied on relatively accurate measurements based on the position of the sun? You could leave Yuma, Arizona, at 10 a.m. and travel the 155 miles or so to Phoenix, Arizona, in 3.5 hours, expecting to arrive at 1:30 p.m. But in Phoenix, they set their clocks 11 minutes earlier at that particular time of year because of what their sundial

clocks were reporting, so according to them, you're arriving at 1:19 p.m. Huh? And that is why we have the institution of standards in time. Keep that in mind as you standardize your camera by setting its clock to the correct time.

In the mid-19th century, you could go on a train trip and arrive ahead of the time you expected.

The 24-Hour Clock

So, what kind of time do you keep? Forget time zones—do you keep a 12-hour clock or a 24-hour clock? If you'll remember from "How to Set the Date and Time" in Chapter 1, "Before You Take Photos," your 6 p.m. arrival home from work happens at 18:00 on a 24-hour clock. Civic services such as the military, police, firefighters, and paramedics use a 24-hour clock as an unambiguous way to keep records of events—such as at what time Bentley the dog took a van for a brief spin through a café window on Long Island, New York, while his owner was inside signing up for open mic night. (Suffolk County Police Fourth Precinct report: November 19, 2008, at 19:10—no one was harmed, the owner got his open mic spot, and Bentley was wagging his tail afterward.)

19:10, November 19, 2008.

For a direct route to the 24-hour clock explained, go to *www. spacearchive.info/military.htm.*

Daylight Saving Time

And what kind of time are you in? FYI, daylight saving time is in the spring and summer (and seems to be getting longer all the time because of laws that went into effect in 2007), and standard time is in the fall and winter. So if you live in Miami, it's July, and you want to set up a conference call with your boss who is on a business trip in Santa Barbara, to look extra fancy, make sure you write in the e-mail, "How's 10 a.m. EDT work for you?" And when she replies with "I'll be playing golf," then change it to later in the afternoon—but don't forget the "EDT"!

Just to make things way more complicated (in the territories of the United States), Hawaii and all of Arizona except for the Navajo Nation, as well as the Aleutian Islands, American Samoa, Guam, the Northern Mariana Islands, Puerto Rico, and the U.S. Virgin Islands do not use the switcheroo on daylight/ standard time at all. They just wanted nothing of it. "Who needs it?!" they said.

Greenwich Mean Time and Coordinated Universal Time

Did you ever wonder what GMT and UTC are? They are Greenwich mean time and Coordinated Universal Time (UTC in French is for Temps Universel Coordonné). Greenwich is in England, and Greenwichers like to think of their GMT time zone as the time zone from which all other time zones were born. And they're pretty much right. UTC and GMT are loosely considered the same thing, but UTC is a more scientifically minded, updated version of GMT, based on a bevy of atomic clocks around the world.

In the United States, our timepiece responsible for contributing to this army of atomic clocks resides at the National Institute of Standards and Technology (NIST) in Boulder, Colorado. This NIST-F1 cesium fountain atomic clock measures the tick of a second in 9,192,631,770 oscillations of a cesium atom. (The NIST-F2, its replacement, is on the way.)

The NIST has a nice little history called "A Walk Through Time: The Evolution of Time Measurement Through the Ages," presented by its physics laboratory, at this site (watch the case-sensitivity): *http://physics.nist.gov/GenInt/Time/time.html*.

Time and Photography

Now, you might be asking, "What in blazes does this have to do with my photos?" Well, your rhetorical curiosity is reasonable. This has nothing to do with your photos. But I want to drill into your subconscious that time is very important to your photo collection.

Photography is instrumental to how our species has understood time. Eadweard Muybridge, a well-known 19th-century photographer, was asked to invent a photographic system to settle a wager by horseman Leland Stanford (also former governor of California, president of the Central Pacific Railroad, and founder of Stanford University), who wanted to know

Remember to set the time correctly on your camera's clock.

whether his horse, Occident, lifted all four hooves off the ground at once during a race in 1872. Stanford was satisfied with the first blurry images that Muybridge produced; indeed it was true—Occident did "fly." But it took 5 more years to perfect this method of freezing time in an unmistakable way. (The 5 years included the slight interruption of a murder trial in which Muybridge was the defendant.) In 1878, Muybridge lined up a 12-camera system alongside Stanford's racetrack in Palo Alto, California, cued to release its shutters by a race-horse tripping wires. The photos were released to the media and represented on the cover of *Scientific American.* Humans had never before been able to see time frozen like that. As explained by James Gleick in his book *Faster: The Acceleration of Just About Everything,* photography "expanded the reach of our eyesight in the temporal domain, as microscopes and telescopes have expanded it in a spatial one."

Eadweard Muybridge photographed the athlete in all phases of motion.

Muybridge went on to photograph athletes, zoo animals, and more horses in all forms of frozen progressive motion. He wasn't the only one enabling new ways of seeing instants in time: Muybridge's contemporary Étienne-Jules Marey was capturing multiple exposures of birds in flight; a few decades later, Harold Edgerton began using flash bursts of light to capture milk hitting a saucer, bullets frozen in the air, and tennis balls smacked by a racquet—all in a blink of light lasting 1/100,000th of a second.

So Much More Than Hours and Minutes

Speaking of seconds, you may be unsatisfied with the limitations of your cell phone time. I mean—hours and minutes? There's more to the time than just hours and minutes. Seconds, milliseconds (1/1,000th), nanoseconds (1/1,000,000,000th), femtoseconds (1/1,000,000,000,000,000th), zeptoseconds (1/1,000,000,000,000,000,000,000th)...OK, maybe that's getting a bit persnickety when it comes to your everyday photo-taking needs. But, these units of time measurement do exist, and I'm guessing that somewhere, in some laboratory dealing with some extremely specific device, someone is asking, down to the femtosecond, what time it is.

Here's how you find out what time it really is (at least down to the second):

- *www.time.gov*: This site uses information from the Time and Frequency Division of the NIST and the U.S. Naval Observatory to show you the time and a picture of what part of the earth is seeing the sun at the moment. It uses Java animation, so if it doesn't work, your computer needs Java like I need java (coffee) in the morning.

- *http://tycho.usno.navy.mil/mc_to.html*: This site explains timekeeping at the U.S. Naval Observatory.

- *http://tf.nist.gov/timefreq*: This is the site of the NIST's Time and Frequency Division, where they really take it down to nanoseconds.

- *http://wwp.greenwichmeantime.com*: For wads o' GMT, this takes the biscuit.

- *www.bipm.org/en/scientific/tai*: For additional European-oriented time information, check out the International Bureau of Weights and Measures (BIPM).

- *www.iers.org*: If you just want to set your head spinning for a while, check out the Web site of the International Earth Rotation and Reference Systems Service (IERS), an organization that helps keep things on time when those vibrating cesium atoms of the NIST-F1 cesium fountain atomic clock at the NIST get out of whack with Earth time. This organization keeps tabs on Earth's rotation in relation to other celestial bodies and advises on when to add leap seconds to our official time.

Now, go check the accuracy of the clock on your camera. Then read up on file formats in Appendix B. ■

The IERS keeps our cesium atoms vibrating to the right time.

appendix B
File Formats

Are you curious to know more about those little three-letter extensions after your photo filenames, like the ".jpg" in IMG_0432.jpg? Do you want to know more about what in the world *lossy* and *lossless* mean? Well, read on—here's some information on file formats for you.

JPEG (Joint Photographic Expert Group)

Typically, your everyday point-and-shoot digital camera will shoot in the JPEG file format, which is what the .jpg file extension represents.

JPEGs are always compressed in a lossy way that literally, but intelligently, removes information from the data of the file to reduce the file size. (I've always wondered if *lossy* was a word before digital cameras, and I just found out that it was. It's a word from the late '40s to describe any sort of loss of energy over an electronic transmission. So there you go!)

The word *lossy* has its roots in the '40s to describe a diminished quality due to a loss of energy over a transmission.

If you simply open a JPEG and then close it, it doesn't compress any more, and you don't lose any information. But if you make any changes to the image and then save the file, or if you use the Save As function under the File menu, the image is taken through the compression rigmarole again and will lose a little more information that you'll never get back.

When you save a JPEG, you'll notice that you can choose different levels of quality in the JPEG Options box that appears in your image-editing software. The lower the number, the smaller the file will be, but you'll be swimming in lossy compression and be discarding your image information left and right. This is not so apparent in smaller prints of your photos, and it works well for posting a photo online, but if you ever make a 13 x 19 print, you might see the loss in quality.

And one more technical thing about JPEGs: They use RGB color channels with 8 bits per channel, which means you get millions of colors available in the image that are based on the brightness of each color value.

TIFFs (Tagged Image File Format)

TIFF files are generally larger in file size than JPEG files, can be compressed without discarding image information, and have a few more options in terms of color space and file structure than do JPEGs:

- TIFFs are capable of 16-bit color (meaning trillions of colors rather than the millions of JPEGs).

- TIFFs support the alternate color space of CMYK with four color channels that subtract colors from absolute white (as opposed to the three RGB color channels of JPEGs that determine color value by its brightness).

- TIFFs support multiple layers in one file, readable by image-editing applications (whereas JPEGs are always "flat" images with one layer).

TIFFs can also exist uncompressed, but they support lossless file compression. (Lossless has roots that are older than lossy, from the '30s. I guess as the years advance, technology comes up with new ways to lose data!) The only way a TIFF will lose data is if you take data out of the image; for instance, if you crop out the garbage truck that's driving by in the background of a photo of you and your friend, the file size will now be smaller.

TIFFs are often considered the standard file format to use when libraries digitize the materials of their collection by scanning them to digital files. Librarians appreciate the option of the 16-bit color space for more closely representing an original printed photograph or document with those trillions of colors (rather than just measly old millions). Even when compressed, a TIFF can be considered higher in quality than the compression of a JPEG and therefore more suitable to the digital archives of a library.

GIFs (Graphics Interchange Format) and PNGs (Portable Network Graphics)

You might come across GIFs and PNGs if you download images from the Internet (which I assume you'll be filing in your Reference folder, as described in "Found Photos for Keeps" in Chapter 7, "Photos from Friends and Found Images"). These are file formats that also support lossless compression but are limited in their color, with a total of 256 color values from which to choose. In other words, GIFs and PNGs are very limited in depicting a blue flower with the color variation that you might see with your own eye, whereas a JPEG has those millions of color brightness values to work with. But for Web site use, the GIF can also support animation, and both GIFs and PNGs can support transparency, meaning that you can create an image that is not limited to appearing in the shape of a rectangle. GIFs and PNGs are more often used for logos and other Web site graphics that are not photographs.

Raw Photos

Raw, when it comes to photos, is not a file format but a way to describe a group of proprietary file formats that different camera companies have developed. A raw photo file has information that was written to the camera's sensor, but that

information has not been processed, or put together (known as *interpolation*), in the camera.

The idea is that you, the photographer, will process the photo and output it as a JPEG, as a TIFF, or as another format using software such as the Adobe Photoshop Camera Raw plug-in.

It's like getting all the ingredients for a birthday cake rather than the cake itself. It's up to you to mix the ingredients together, toss the cake in the oven, and then ice the darned thing. But don't get me wrong—raw file conversion is great. It allows you to seriously craft your photos exactly the way you want them to look. But then again, I like baking, too.

Processing a raw file is like baking a cake from multiple ingredients.

I think of raw as being like the film negative of yore. And I think that in the future it will be the standard way that all cameras will shoot. The only problem with raw right now is that all raw file formats (such as the Nikon NEF, the Canon CR2 or CRW, and the Olympus ORF, among hundreds of others) are

completely proprietary to the cameras that make them. So if your particular camera manufacturer goes out of business or merges with another company, it's possible that other software manufacturers will discontinue making applications that will open your old camera files down the line. And that brings us to the next format: DNG.

DNG (Digital Negative)

DNG is a type of raw file format that Adobe developed to avoid all this proprietary gobbledygook. The specifications for the DNG format are publicly available. Adobe's idea is that photographers will convert their raw files to DNGs and thus have a photo archive that will never become obsolete in its formatting (and Adobe provides a free Adobe DNG Converter).

DNG has a lot of perks other than its potential life span of accessibility. Digital asset management guru Peter Krogh, author of *The DAM Book: Digital Asset Management for Photographers, 2nd Edition*, has described it this way: The DNG file format is like a bucket, in which a lot of information about a particular image file is held. This includes your unprocessed image information, any processing information that you create (held in metadata such as XMP, EXIF, or IPTC), a JPEG preview of the image (set to the compression quality of your choice), and the entire original proprietary raw file, if you want to toss that in there, too. All this for free! That is, it's free as long as you have software to turn the DNG files into JPEGs, TIFFs, or other formats. ■

Not to mix metaphors too much, but as an archival format, DNG can serve as an umbrella for your photo files, as well as a bucket.

appendix C
Metadata

In digital photography, *metadata* is information about your photo embedded within the photo file. Some metadata can be added or edited, and some is absolute. You may not know it's there—but it is, always. While you're "taking a picture" of your cat, your camera is "taking the information" of your camera the moment you press the shutter button. Aren't you lucky you get to enjoy the cat photo while your camera gets the boring old information?

The camera is taking note that this photo was shot on May 28, 2009, at f/4.2 with a 1/15 shutter by a Canon PowerShot camera. Mr. Digishoe is taking note that this is the cutest little cat he's ever seen!

However, some people do not find this information boring at all. By taking control of metadata and applying the assistance of powerful software, you can use this embedded information in individual photos (of a collection of thousands) to catalog, categorize, rate, and sort in a multitude of extremely useful ways. Remember the section on keywords and categories ("Keywords—Tag! Your Photo Is It" in Chapter 3, "Navigating a Sea of Photos")? Those keywords and categories are metadata. It's magical, really, because metadata is both automatic (the moment the shutter clicks) and mutable (when you add it later) in ways that tell you about your photos.

Have you ever signed up for a Facebook or MySpace account and filled out your profile information? Your gender, birthday, hometown, relationship status, high school and college attended, and likes and dislikes are all metadata about you. Some of that information is subjective, such as your likes and dislikes. Some of the information, like your birthday, is set in stone. Photo metadata has different types of information as well. The most common that you might come across fall into three types: EXIF, IPTC, and XMP.

EXIF

Exchangeable Image File Format (EXIF) information is automatically embedded into your photo when you take it, including the time and date, the camera model, any settings, and the pixel dimensions. This information is like the profile information on your Facebook page that doesn't change, such as your birth date.

IPTC

International Press Telecommunications Council (IPTC) information is added to the photo after it's taken. You may remember from "Beyond the Box: Pro Navigating Techniques" in Chapter 3 that Photo Mechanic was designed for photojournalists and that it uses IPTC information. IPTC was developed for the press and media too (note the *P* for "press" in that acronym). In the old days, photographers would provide prints to their editors with notes written either on the back or in an accompanying document to denote who took the photo and as much information on what was going on in the image as possible. Today, that information comes in the form of photo metadata.

Press photographers used to hand in notes with their photos.

Your IPTC can work with your EXIF. For instance, IPTC reads the date and time from your EXIF and can use that in the IPTC date and time field. But say you scan an old photo of your parents on their wedding day to a JPEG file format. The EXIF information for that photo file will be created upon scanning— but that's not when your parents got married! (Unless you took a digital photo the day of their wedding, downloaded it to your computer, printed it on your portable digital photo printer, and then scanned that print to make a new JPEG on the same day, which makes no sense at all—just go have fun at the reception! Wait—you weren't even born yet! Oh, my head hurts!) With IPTC information, you can insert the marriage date in the IPTC date field to have that date associated with that image. The date and time in the EXIF will remain the same.

This photo of my dad and his two brothers was scanned on November 9, 2008, but I know it was taken in July 1949. So, I'll put that date in the IPTC information.

XMP

Extensible Metadata Platform (XMP) was developed by Adobe Systems with the intention of improving on (and possibly replacing) the capabilities of IPTC information. In addition to informative data like contact information for a photo, XMP can also include image adjustment information. This is often stored on the outside of a photo file in what is called a *sidecar file*. When a raw file is adjusted by using the Adobe Photoshop Camera Raw (ACR) plug-in, ACR creates a sidecar file with metadata representing that adjustment information; the sidecar file has the same filename base as the photo and has a suffix of .xmp. Subsequently, the next time you open the raw photo in ACR, ACR automatically opens and reads the XMP file and displays those adjustments.

The DNG file format stores XMP information in its bucket—mentioned in the "DNG (Digital Negative)" section in Appendix B—within the information of the DNG itself, not as a sidecar file.

In Adobe Photoshop Lightroom, the XMP adjustment and other metadata stays within the world of the Photoshop Lightroom software until you tell it to write the XMP adjustments to your photo by syncing the information or exporting the photo as an adjusted image.

Not all software reads all kinds of metadata. For instance, Preview 4.1 does not show XMP information in its information inspector (which can be accessed via Tools, previously Get Info in earlier versions of Preview), but it does show some fields from IPTC and EXIF. Generally speaking, most professional image-editing and browsing software always reads EXIF and tends to combine IPTC and XMP. Photo Mechanic does this in its IPTC information pane and lets you know which fields are saved only in XMP. ∎

IPTC and EXIF tend to work together.

glossary

ADC *See* analog to digital converter (ADC).

analog to digital converter (ADC) Converts electric signals from the photosites of a camera's sensor to a binary code of zeros and ones to digitally represent an image.

aperture An adjustable hole within the lens of a camera that lets light pass onto a camera sensor.

archive (file compression) A file that contains multiple compressed files that can be uncompressed to their original size using an application.

archive (photo collection) A dedicated protected media for the long-term storage of digital photos in which photo files are left untouched once they enter and new photos are added on a regular basis.

audiovisual interleave (AVI) A common file format used by digital still cameras for movies with sound.

AVI *See* audiovisual interleave (AVI).

bit A portmanteau word for binary and digit representing the smallest measurement of computer data. One bit is valued at either zero (off) or one (on).

byte A group of 8 bits.

camera sensor A surface behind the lens of a camera made up of light-sensitive photosites from which light is converted to electrical current.

card reader A device that allows access by a computer to photo files on the removable memory card in a camera.

CCD sensor *See* charge-coupled device (CCD) sensor.

charge-coupled device (CCD) sensor A type of camera sensor (often found in compact cameras) that converts light to voltage but sends that signal off-sensor as analog information.

color cast An overall abnormal hue that looks unnatural in an image.

contact sheet A way of displaying thumbnail-sized versions of multiple images; the term comes from the process of laying a cut roll of negative to photo paper to produce a contact image of all frames in the roll.

Coordinated Universal Time (UTC) A standard of time, based on information gathered from multiple atomic clocks around the world, that has leap seconds added as needed to compensate for changes in the earth's rotation.

copyright The right to make and distribute copies of a created work for personal gain; enforced by law.

copyright infringement The act of breaking copyright law by distributing or making copies of a copyrighted work for personal gain.

daisy chaining Connecting two or more devices to each other with the ability for accessing information on those devices.

depth of field The area surrounding the main focal point of a photo that remains in focus.

digital negative (DNG) A type of raw file that includes, in one file, unprocessed image information, any processing information (held in metadata such as XMP, EXIF, or IPTC), a JPEG preview of the image (set to the compression quality of your choice), and the capability of including the entire original proprietary raw file.

digital single-lens reflex (DSLR) The digital version of a single-lens reflex (SLR) camera in which the same lens is used for both viewing and capturing the image; typically allows for interchangeable lenses.

DNG *See* digital negative (DNG).

dots per inch (dpi) In printing, a resolution term applying to the number of ink dots that fit into 1 inch on the printing surface.

dpi *See* dots per inch (dpi).

DSLR *See* digital single-lens reflex (DSLR).

exchangeable image format (EXIF) A type of metadata that records information about the camera conditions in which a photo is taken, for instance the camera model, time and date, ISO, shutter, and aperture.

extensible media platform (XMP) A set of metadata headers developed by Adobe Systems with the intention of improving on (and possibly replacing) the capabilities of IPTC information. XMP can include image adjustment information that can be stored on the outside of a photo file in a sidecar file. *See also* sidecar file *and* International Press Telecommunications Council (IPTC) photo metadata.

EXIF *See* exchangeable image format (EXIF).

fair use A limitation of copyright law found in circumstances when the use of a copyrighted work is for criticism, comment, news reporting, research, scholarship, or teaching.

file compression A technique to reduce the size of a file.

file format The way the data of an image is encoded as a computer file.

file number reset A setting in most cameras that allows you to reset the file numbering to zero each time the camera's memory card is formatted.

FireWire A method of transferring data to and from a computer from external devices via a plug-in port. Data can be transferred between two FireWire-connected devices with only one of those devices being connected directly to a computer (called *daisy chaining*). *See also* daisy chaining.

flash memory A form of rewritable and reprogrammable storage that does not need its own power source and has no moving parts.

format To overwrite all photos from a memory card in a camera and to initialize the card for more shooting. The regular formatting of a memory card can help prevent the corruption of the memory card.

f-stop A measurement used to describe the size of the aperture of a lens. Lower-numbered f-stops are wider, letting in more light, but they provide less depth of field than higher, narrower f-stops. *See also* depth of field.

GB *See* gigabyte (GB).

gigabyte (GB) Equal to 1,024 megabytes.

GIF *See* Graphics Interchange Format (GIF).

Graphics Interchange Format (GIF) A file format that is widely used on Web sites and for short animations; limited to 256 colors as an 8-bit file.

hard drive (external) A data storage device that is usually connected to your computer by FireWire, universal serial bus (USB), or Serial Advanced Technology Attachment (SATA); used for portable storage, for backup, or to boost the storage space of a computer system overall.

hard drive (internal) The hard drive that exists inside a computer.

International Press Telecommunications Council (IPTC) photo metadata Administrative, descriptive, and rights metadata about a photo file that is processed by software.

International Standards Organization (ISO) A rating system that expresses a camera sensor's adjustable sensitivity to light. Higher ISO ratings amplify the sensor's sensitivity.

IPTC photo metadata *See* International Press Telecommunications Council (IPTC) photo metadata.

ISO *See* International Standards Organization (ISO).

Joint Photographic Experts Group (JPEG) A standard for lossy compression of image files that can reduce a file size by 10 to 20 times.

JPEG *See* Joint Photographic Experts Group (JPEG).

KB *See* kilobyte (KB).

keyword A descriptive word assigned within the metadata of an image to aid in explaining, finding, or putting value on that image at a later time. Also referred to as a *tag*.

kilobyte (KB) Equal to 1024 bytes.

lossless Used to describe any sort of file compression that does not compromise the data of the file while reducing file size.

lossy Used to describe any sort of file compression that omits data from the file in order to reduce file size.

MB *See* megabyte (MB).

megabyte (MB) Equal to 1024 kilobytes.

megapixel (MP) A resolution of 1 million pixels.

memory card A flash-based form of photo storage that is removable from a camera.

metadata Information along with or embedded in a file that indicates and describes multiple aspects of the file.

MOV *See* QuickTime movie format (MOV).

MP *See* megapixel (MP).

online photo host A service that provides storage for a photo collection, usually redundant and on multiple servers in multiple locations, that is uploaded to and accessed online.

photodiode A light detector that converts light information gathered from pixels on a camera sensor to electrical current.

pixel A portmanteau word for picture element; a unit of measurement for the light-gathering elements on a camera's sensor.

pixels per inch (ppi) A measurement for the resolution of an image based on how many pixels are represented in 1 square inch of the displayed image.

Portable Network Graphics (PNG) An alternative lossless image format to GIF, used mostly for Web sites.

PNG *See* Portable Network Graphics (PNG).

ppi *See* pixels per inch (ppi).

QuickTime movie format (MOV) A common file format used by digital still cameras for movies with sound.

raw A proprietary file format that requires processing on a computer.

shutter speed The speed at which the camera sensor is exposed to the light of an image.

sidecar file A way to store metadata about a file in an independent file, usually with the same filename base; to be opened automatically by image-editing software in conjunction with the original file.

synchronization The act of two things happening at the same time (for example, two clocks in two cameras set to the same time and date).

tag *See* keyword.

universal serial bus (USB) A method of transferring data to and from external devices via a plug-in port on a computer. USB devices cannot be daisy chained. *See also* daisy chaining.

USB *See* universal serial bus (USB).

USB flash drive A rewritable portable flash-based storage device that plugs into the USB port on a computer. A USB flash drive has no internal moving parts and is known for its small size.

UTC *See* Coordinated Universal Time (UTC).

white balance A setting in-camera that determines what, in the frame, is considered true white under different color temperatures of light such as tungsten, daylight, clouds, and fluorescent.

XMP *See* extensible media platform (XMP).

Index

Numbers

4 × 6 prints
 megapixel rating for, 106
 printer suggestion, 96
8 × 10 prints, lowest megapixel rating for, 106

A

ACDSee software, cost of, 44
ACR (Adobe Photoshop Camera Raw) plug-in,
 use of, 141
ADC (analog to digital converter), defined, 144
Adobe Bridge software, features of, 44
Adobe Photoshop Elements, renaming tool in, 7
AF (Auto Focus) mode, explained, 12
American Library Association Web site, 115
aperture, defined, 144
Aperture software, features of, 44
archive, defined, 144
AsukaBook photo book service Web site, 104
Auto-Open function, disabling, 74–77
AVI (audiovisual interleave), defined, 144
AWB (Auto White Balance), explained, 11

B

Backblaze Web site, 61
Backup 3 Web site, 61
backups. *See also* storage options
 automatic, 54
 creating for laptops, 55
 creating for photos, 52–53
 creating with Time Machine, 65–67
 on DVDs, CDs, and Blu-ray discs, 62–63
 on flash drives, 59
 importance of, 56–57
 on iPods and MP3 players, 58
 Mac only, 61
 on online services, 59–61
 relating to internal hard drive space, 52
 software Web sites, 67
 Windows, 61
batch file naming, application for, 7
A Better Finder Rename Web site, 7
bit, defined, 144
Blu-ray discs, backing up photos on, 63

Blurb photo book service Web site, 104
brain, positive effect of journals on, 38
browser, dragging and dropping photos in, 110
browsing photos, 39–42
browsing software, features of, 43–45
buffer, leaving for hard drive space, 54
byte, defined, 144

C

calendar, keeping, 37–42
calotypes, invention of, 119
camera icon, function of, 8–9
camera sensor, defined, 144
cameras
 comparing features, 19–20
 number of megapixels, 18
 prices, 18
 sizes, 19
 syncing with partners, 7
Carbonite Web site, 61
card readers
 defined, 144
 using, 84–85
categories, creating, 37
CCD (charge-coupled device) sensor, defined,
 6, 144
CDs, backing up photos on, 62
ChronoSync backup software Web site, 67
clock
 24-hour, 125–126
 setting, 10
CMOS sensor, explained, 6
color cast, defined, 144
color labels, applying to photo files, 92
color printing, perfecting, 96. *See also* printing
Command key. *See* keyboard shortcuts
contact sheets
 defined, 145
 printing, 47–48
Coordinated Universal Time (UTC), defined, 145
copying files, 91
copyright
 defined, 145
 duration of, 114–116
 protection offered by, 112
 registering for, 113–114

CrashPlan Web site, 61
Ctrl key. *See* keyboard shortcuts

D

daguerreotypes, explained, 119
daisy chaining, defined, 52, 145
Data Robotics Web site, 64
data sticks, backing up photos on, 59
date and time, setting, 8–10
daylight saving time, 126
DCIM (Digital Camera Image) folder
 displaying in DiskAid, 78–79
 multiple folders in, 80
Déjà Vu backup software Web site, 67
deleting photos, 12, 83
depth of field, defined, 145
digital calendar, keeping, 37–42
Digital Photography Review Web site, 19
DiskAid, downloading photos on Windows
 with, 78
DNG (Digital Negative) file format, 136
 defined, 145
 XMP information in, 141
downloading photos
 avoiding duplicates, 80–81
 disabling Auto-Open function, 74–77
 formatting memory cards, 82–83
 with Image Capture on Macs, 78
 manually, 77, 79
 wireless transfer, 86
dpi (dots per inch), defined, 145
Drobo drive
 cost of, 65
 Web site, 64
DSLR (digital single-lens reflex), defined, 6, 145
DVDs, backing up photos on, 62

E

Elements, renaming tool in, 7
EMC Retrospect backup software Web site, 67
e-mailing photos, file-size considerations, 100
European time information, accessing, 129
EXIF (Exchangeable Image File Format),
 defined, 139, 146
Expression Media
 features of, 44
 finding iPhoto photos with, 30
external hard drives
 portability of, 55
 shopping for, 51

Eye-Fi memory cards, downloading
 photos with, 86

F

fair use, defined, 112, 146
*Faster: The Acceleration of Just About
 Everything*, 128
file compression, defined, 146
file formats
 defined, 146
 DNG (Digital Negative), 136
 GIFs (Graphics Interchange Format), 134
 JPEG (Joint Photographic Expert Group),
 132–133
 PNGs (Portable Network Graphics), 134
 raw, 134–136
 TIFFs (Tagged Image File Format), 133–134
file naming, application for, 7
file number reset
 defined, 146
 setting, 13–14
filenames, using with contact sheets, 47
files. *See also* photos
 copying and pasting, 28
 retaining originals, 31
 selecting all, 40
FireWire, defined, 146
flash drives, backing up photos on, 59
flash memory, defined, 146
Flickr, storing photos on, 60
folders
 creating, 24
 creating Print, Share, and Reference, 89
 organizing, 110–111
format, defined, 146
Format option, displaying for memory cards, 83
Fotki online printing service Web site, 103
Friends-Family-Photos subfolder, creating, 108
f-stop, explained, 12, 147

G

Gasaway, Lolly, 115
GB (gigabyte), measurement of, 147
Genie Backup Manager Home backup software
 Web site, 67
geotagging feature, using with Eye-Fi, 86
GIFs (Graphics Interchange Format) file format,
 defined, 134, 147
Gleick, James, 128
GMT (Greenwich mean time), 127, 129

H

hard drives
 backing up photos on, 52
 comparing, 63
 external, 51
 external versus internal, 147
 leaving buffers for, 54
 saving photo masters on, 51
heliograph, production of, 119
High Quality setting, choosing, 16–17
Hitachi Global Storage hard drives Web site, 63
home printing
 with Preview on Macs, 104–105
 with Windows Photo Gallery, 105–106
huey, using with monitor calibration, 96

I

iCal calendars, keeping, 37
IERS (International Earth Rotation and
 Reference Systems Service), 130
Image Capture, using on Macs, 78
image-browsing software
 features of, 43–44
 image editing in, 31
images, dragging and dropping in browsers, 110
Info box, opening in Mac OS X, 58
interpolation, defined, 135
iPhoto photos, finding on Macs, 28–30
iPhoto software
 disabling Auto-Opening in, 75–76
 features of, 44
iPods, backing up photos on, 58
IPTC (International Press Telecommunications
 Council), 139–140, 147
ISO, explained, 11

J

journals, positive effect on brain, 38
JPEG (Joint Photographic Expert Group) file
 format, shooting in, 15, 132–133, 147

K

KB (kilobyte), measurement of, 148
keyboard shortcuts
 copying and pasting, 32
 copying files, 28
 copying photo files, 91
 displaying size of photo files, 100

dragging and dropping photos in browser, 110
 pasting files, 28
 pasting photo files, 91
 selecting all files, 40
 selecting photos, 32
keywords
 defined, 147
 using, 45–46
Kind column, displaying in List view, 33
Kodak Gallery online printing service
 Web site, 103
Krogh, Peter, 63, 136

L

labels, applying to photo files, 92
LaCie hard drives
 2big Triple, 65
 Rugged Hard Disk, 55
 Web site, 63
laptops, creating backups for, 55
Lexar memory cards, features of, 86
Lightroom software
 features of, 44
 metadata in, 142
List view
 accessing, 26
 displaying Kind column in, 33
lossless, defined, 148
lossy, defined, 132, 148
Lulu photo book service Web site, 104

M

MacGurus hard drives Web site, 63–64
Mail application, resizing photos with, 99
manual camera settings, using, 11–12
master version of photos, creating, 51
Maxtor hard drives Web site, 63
MB (megabyte), measurement of, 148
megapixels, considering number of, 18
Memeo AutoBackup Standard backup software
 Web site, 67
memory cards
 defined, 148
 formatting, 82–83
 quality of, 85
 using, 55
metadata
 defined, 138, 148
 examples of, 44–45, 138
 EXIF (Exchangeable Image File Format), 139

IPTC (International Press
Telecommunications Council), 139–140
XMP (Extensible Metadata Platform), 141–142
metering mode, explained, 12
milliseconds, measurement of, 129
monitor calibration, using huey with, 96
month of photos, browsing, 40–42
MOV (QuickTime movie format), defined, 148
movies, filing and editing, 33
Mozy Web site, 61
MP3 players, backing up photos on, 58
Mpix online printing service Web site, 103
Muybridge, Eadweard, 127–128
MyPublisher photo book service Web site, 104

N

nanoseconds, measurement of, 129
Niépce, first photo made by, 119–120
NIST's Time and Frequency Division, 129
NTI Backup Now backup software Web site, 67
Number Reset
defined, 146
setting, 13–14

O

online photo host, defined, 148
online printing, considering, 103–104
online services, backing up photos on, 59–61
Open With option, accessing, 39
original files, retaining, 31

P

PaperChase photo book service Web site, 104
photo book service Web sites, 104
photo files
color-labeling, 92
copying, 91
determining sizes of, 100
duplicating, 27
printing list of, 91
resizing, 99–100
Photo Gallery
displaying in Windows, 42
home printing with, 105–106
resizing photos with, 100
photo labs, developing relationships with, 97
Photo Mechanic, features of, 43–45
photo printer, using with 4 × 6 prints, 96

photo quality, maximizing, 15–17
photo viewer, setting up, 39–40
Photobucket online printing service
Web site, 103
photodiode, defined, 148
photos. See also files
backing up, 52–53
browsing with Preview, 29–30
copyright issues, 112
creating master version of, 51
crediting, 116
deleting, 12, 83
dragging and dropping in browser, 110
duplicating, 32
filing by year and month, 24
filing retroactively, 27–28
finding, 28–30
getting permission for use of, 112–113
history of, 119
organizing from multiple cameras, 25
preserving, 94
printing, 96–97
purging from Photos-Download folder, 54
selecting and duplicating, 90–91
sharing, 108–109
sorting chronologically, 26–27
using publicly, 112
Photos folder, creating subfolders in, 89
Photoshop Elements, renaming tool in, 7
Photoshop Lightroom software, features of, 44
PhotoWorks online printing service Web site,
103
Picasa software, features of, 44
pixel, defined, 148
PNGs (Portable Network Graphics) file format,
defined, 134, 148
ppi (pixels per inch), defined, 148
Preview application
browsing photos with, 29–30
home printing with, 104–105
opening, 40–41
resizing photos with, 99
setting as default, 39–40
print permanence, explained, 93–95
printing. See also color printing
contact sheets, 47–48
home, 104–106
lists of photo files, 91
online, 103–104
photos, 96–97
public domain, resource for, 115

Q

Quality settings, choosing, 16–17
Quick Look function, using, 41
QuickTime movie format (MOV), defined, 148

R

RAID (redundant array of inexpensive disks), 64–65
raw file format, explained, 134–136, 149
Reference folder, contents of, 101–102, 108
RenameMaestro Web site, 7
Renamer4Mac Web site, 7
renaming files, tools for, 7
resolution
 considering for printing, 106
 setting, 16–17
Roxio BackOnTrack backup software
 Web site, 67

S

Seagate Technology hard drives Web site, 63
Second Copy backup software Web site, 67
settings, finding, 8
shared photos, specs, 98–100
Show File Properties option, accessing in
 Windows, 58
shutter speed, explained, 12, 149
Shutterfly
 online printing service, 104
 storing photos on, 61
sidecar file
 contents of, 141
 defined, 149
SmugMug online printing service Web site, 104
Snapfish online printing service Web site, 104
Spyder calibration devices Web site, 96
Stanford, Leland, 127–128
storage options. *See also* backups
 Flickr, 60
 Shutterfly, 61
 Winkflash, 60–61
SuperDuper! backup software Web site, 67
synchronization, defined, 149
SyncToy backup software Web site, 67

T

tags
 defined, 147
 using, 45–46

Talbot, William Henry Fox, 119
thumb drives, backing up photos on, 59
thumbnails, browsing, 47–48
TIFFs (Tagged Image File Format) file format, 133–134
time
 24-hour clock, 125–126
 daylight saving time, 126
 GMT (Greenwich mean time), 127
 UTC (Coordinated Universal Time), 127
 Web sites, 129–130
time and date, setting, 8–10
Time Machine, creating backups with, 65–67
toolbox settings, navigating, 14
toolbox tab, navigating to, 9

U

U.S. Naval Observatory, timekeeping at, 129
USB (universal serial bus), defined, 149
USB flash drives, backing up photos on, 59
UTC (Coordinated Universal Time), defined, 127, 145

V

View from the Window at Le Gras, 120
viewing photos, 39–42

W

Walmart online printing service Web site, 104
WB (White Balance), explained, 11, 149
Web sites
 American Library Association, 115
 AsukaBook photo book service, 104
 Backblaze storage options, 61
 Backup, 3, 61
 backup software, 61, 67
 A Better Finder Rename, 7
 Blurb photo book service, 104
 calendars, 37
 Carbonite storage options, 61
 ChronoSync backup software, 67
 CrashPlan storage options, 61
 Data Robotics, 64
 Déjà Vu backup software, 67
 Digital Photography Review, 19
 DiskAid, 78
 Drobo drive, 64
 EMC Retrospect backup software, 67
 Flickr, 60

Fotki online printing service, 103
Genie Backup Manager Home backup
 software, 67
GMT (Greenwich mean time), 129
hard drives, 63
Hitachi Global Storage hard drives, 63
Kodak Gallery online printing service, 103
LaCie hard drives, 63
Lulu photo book service, 104
MacGurus hard drives, 63–64
Maxtor hard drives, 63
Memeo AutoBackup Standard backup
 software, 67
Mozy storage options, 61
Mpix online printing service, 103
MyPublisher photo book service, 104
NIST's Time and Frequency Division, 129
NTI Backup Now backup software, 67
online printing services, 103
PaperChase photo book service, 104
photo book services, 104
Photobucket online printing service, 103
PhotoWorks online printing service, 103
RenameMaestro, 7
Renamer4Mac, 7
Roxio BackOnTrack backup software, 67
Seagate Technology hard drives, 63
Second Copy backup software, 67
Shutterfly, 61
Shutterfly online printing service, 104
SmugMug online printing service, 104
Snapfish online printing service, 104
Spyder calibration devices, 96
SuperDuper! backup software, 67
SyncToy backup software, 67
time, 129–130
Time Machine backup software, 67

U.S. Copyright Office, 116
Walmart online printing service, 104
Western Digital hard drives, 63
"When U.S. Works Pass Into the Public
 Domain," 115
WildRename, 7
Winkflash online printing service,
 60–61, 104
WIR (Wilhelm Imaging Research), 95
Western Digital hard drives Web site, 63
White Balance (WB), explained, 11, 149
WildRename Web site, 7
Windows
 disabling Auto-Opening in, 76–77
 displaying Photo Gallery in, 42
 setting default preview application in, 40
Windows Photo Gallery
 home printing with, 105–106
 resizing photos with, 100
Winkflash
 online printing service, 104
 storing photos on, 60–61
WIR (Wilhelm Imaging Research), 94–95
wireless transfer, downloading photos with, 86
World Time function, setting, 9
wrench settings, navigating, 14
wrench tab, navigating to, 9

X

XMP (Extensible Metadata Platform), defined,
 141–142, 146

Z

zeptoseconds, measurement of, 129